Miami at Night! Best wishes always,
Bill Brathe

BILL BROTHERS

MIAMI
AT NIGHT

Schiffer Publishing Ltd®

Other Schiffer Books on Related Subjects:
Boston Wide, ISBN: 978-0-7643-3273-9
Windows on Central Park, ISBN: 978-0-7643-3835-9
Miami: Past and Present. ISBN: 978-0-7643-3623-2

Library of Congress Control Number: 2015950938

Designed by Brenda McCallum
Cover design by Justin Watkinson
Type set in Broadway/ Mensch

ISBN: 978-0-7643-5028-3
Printed in China

Published by Schiffer Publishing, Ltd.
4880 Lower Valley Road
Atglen, PA 19310
Phone: (610) 593-1777; Fax: (610) 593-2002
E-mail: Info@schifferbooks.com

For our complete selection of fine books on this and related subjects, please visit our website at www.schifferbooks.com. You may also write for a free catalog.

This book may be purchased from the publisher. Please try your bookstore first.

We are always looking for people to write books on new and related subjects. If you have an idea for a book, please contact us at proposals@schifferbooks.com.

Schiffer Publishing's titles are available at special discounts for bulk purchases for sales promotions or premiums. Special editions, including personalized covers, corporate imprints, and excerpts can be created in large quantities for special needs. For more information, contact the publisher.

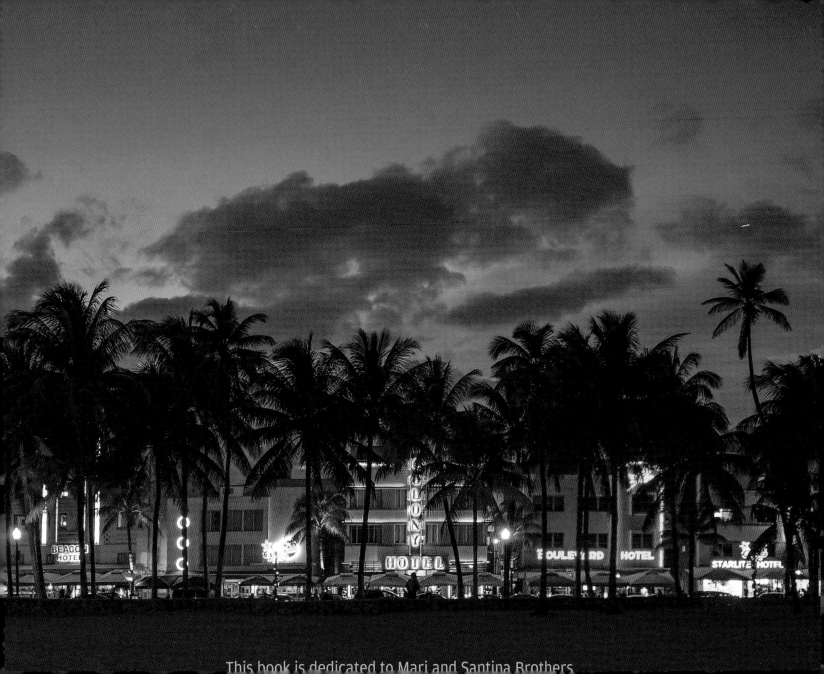

This book is dedicated to Mari and Santina Brothers

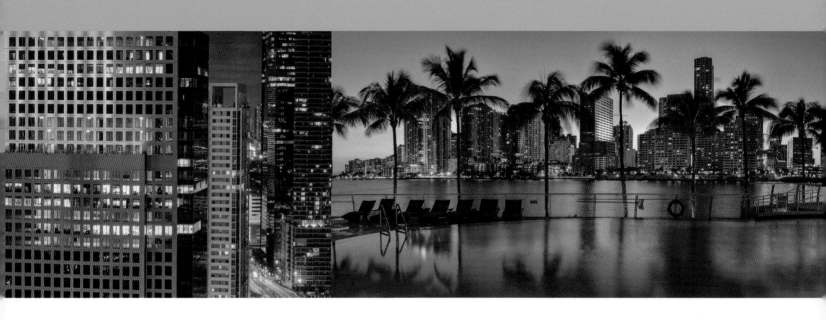

Miami is one of those great places that is a really sensual, physically beautiful place.
Michael Mann, Filmmaker

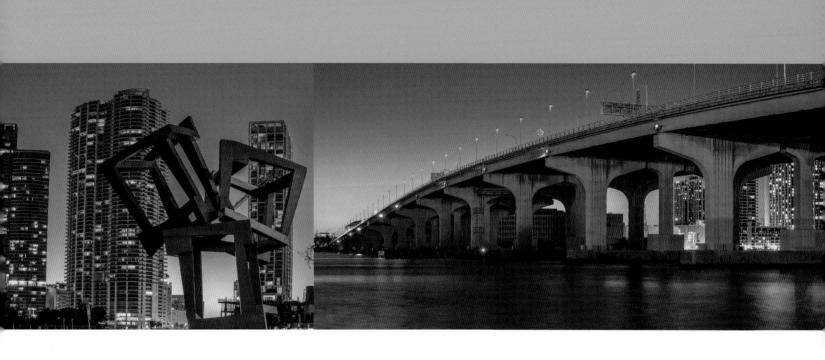

CONTENTS

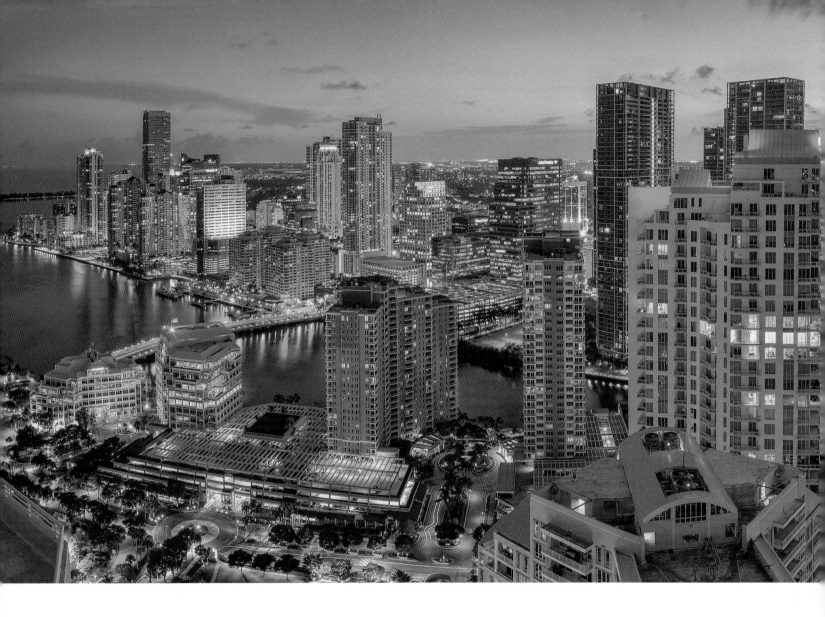

PART 1 BRICKELL AND BRICKELL KEY

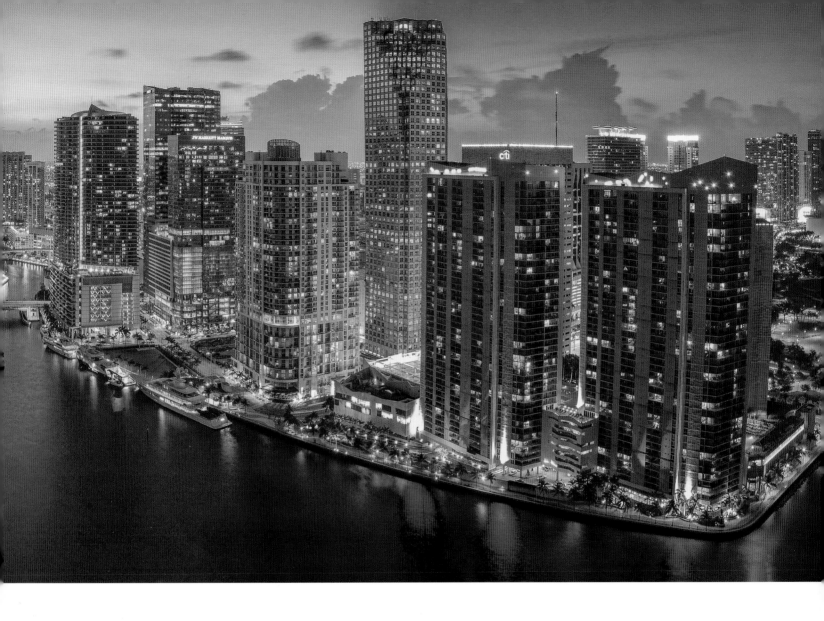

Night view of Downtown Miami, Brickell, and Brickell Key

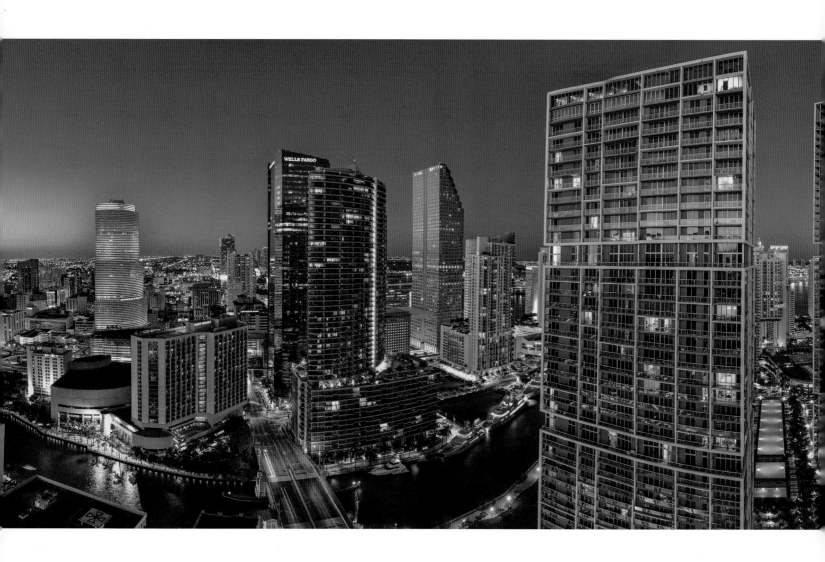

Panoramic view of Downtown Miami and Brickell

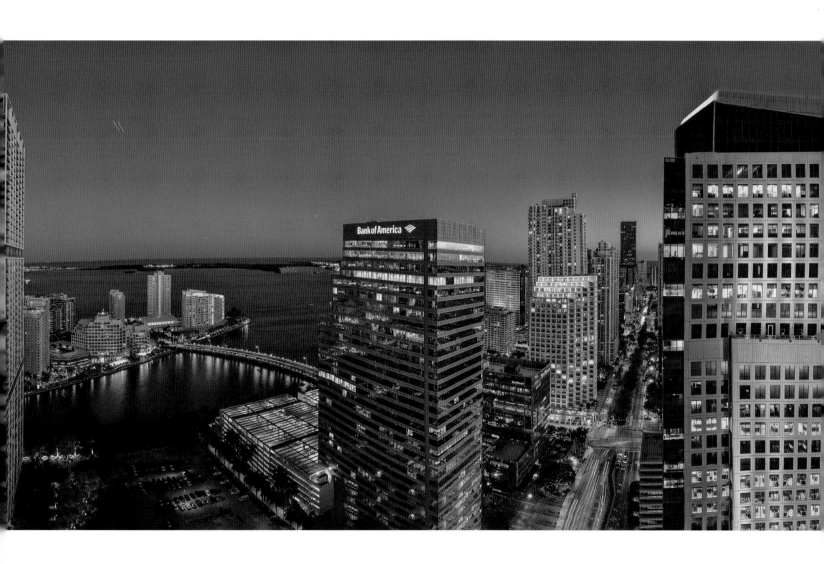

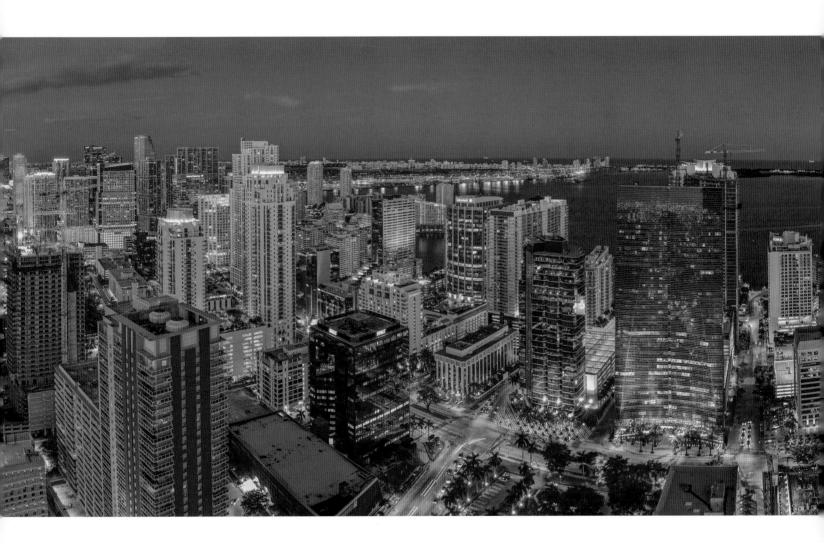

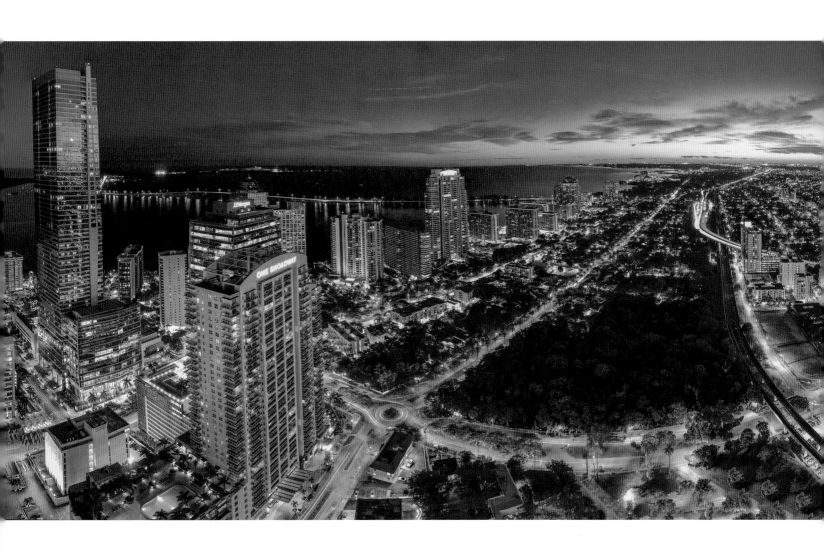

A typical Miami sunset overlooking Brickell and Biscayne Bay

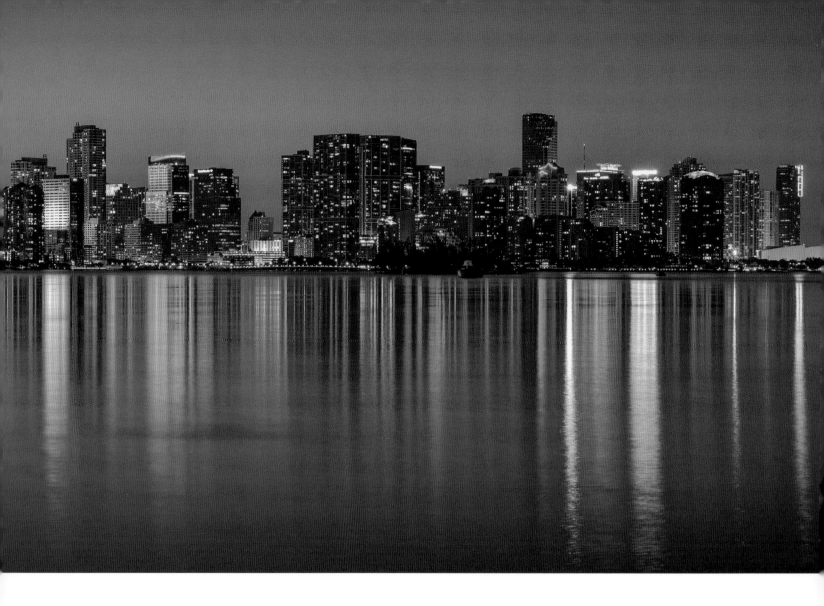

The Brickell skyline coming to life at night

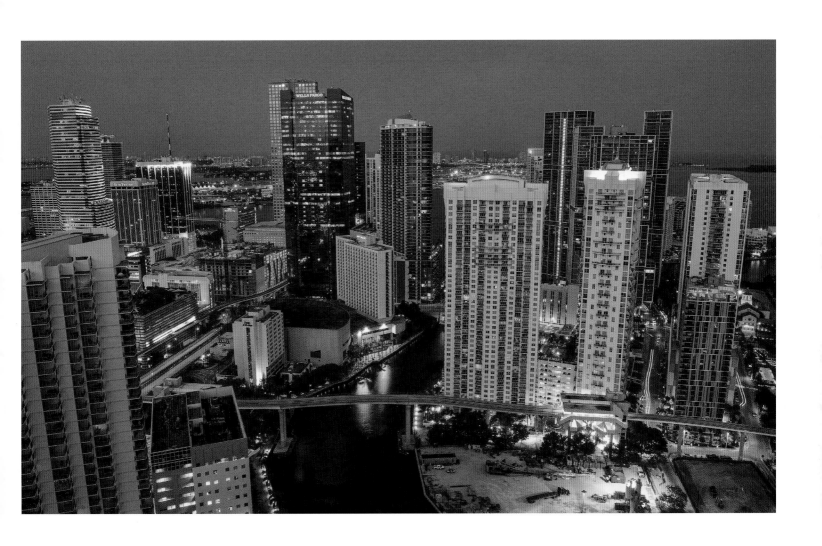

The colorful towers of Miami over the Miami River

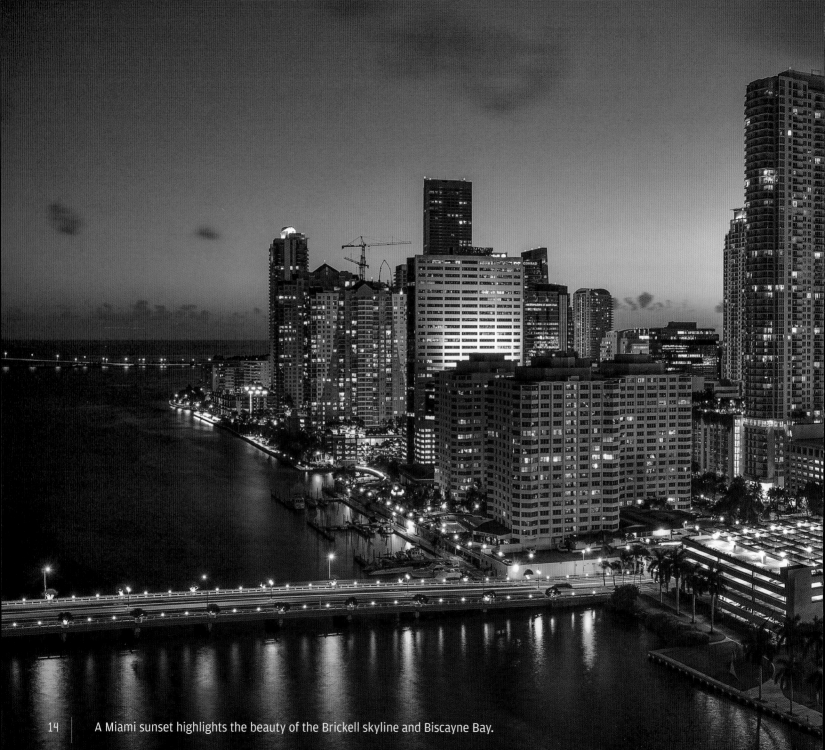

A Miami sunset highlights the beauty of the Brickell skyline and Biscayne Bay.

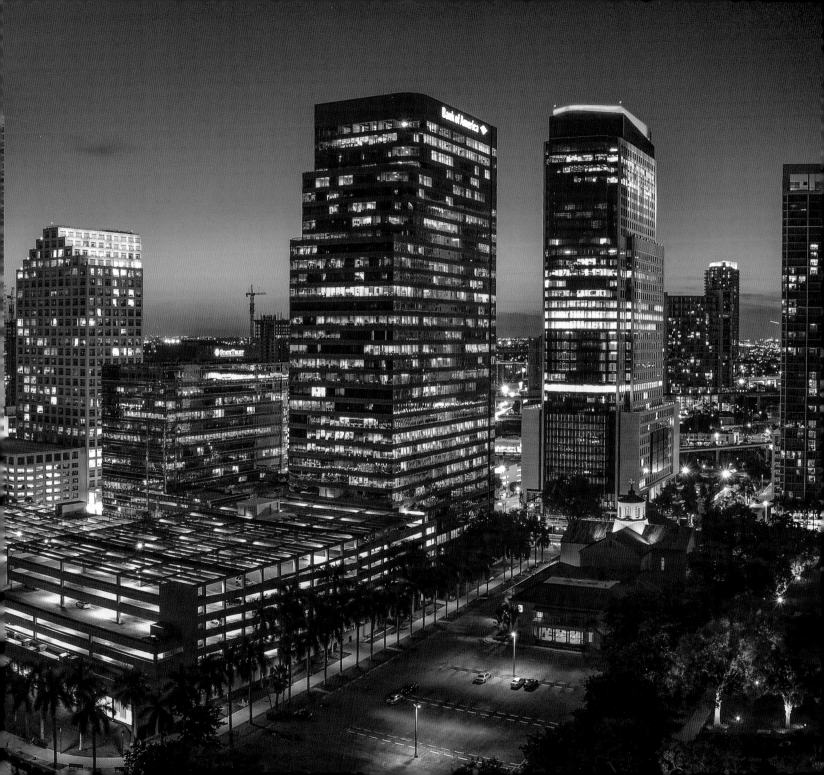

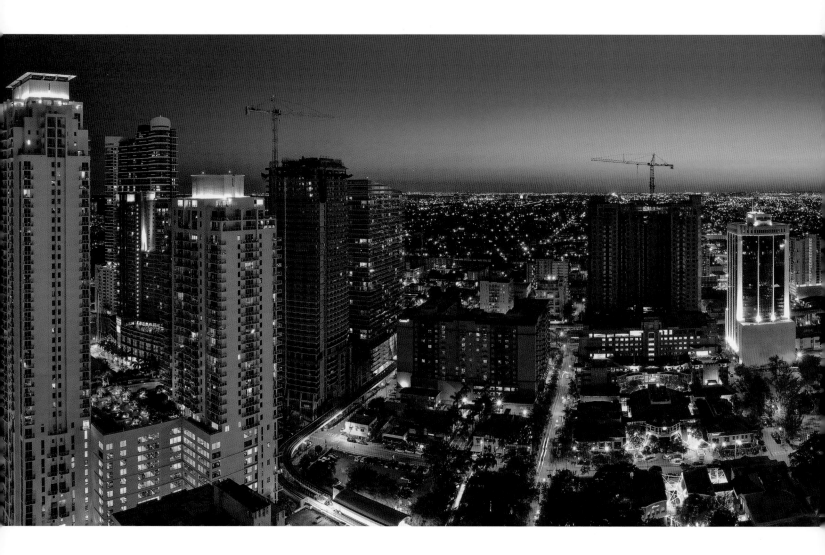

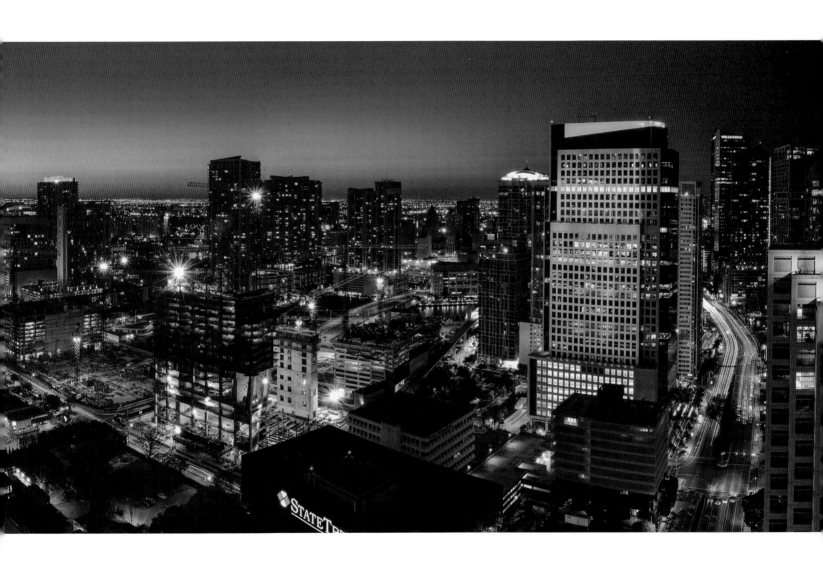

Panoramic view of the heart of Brickell

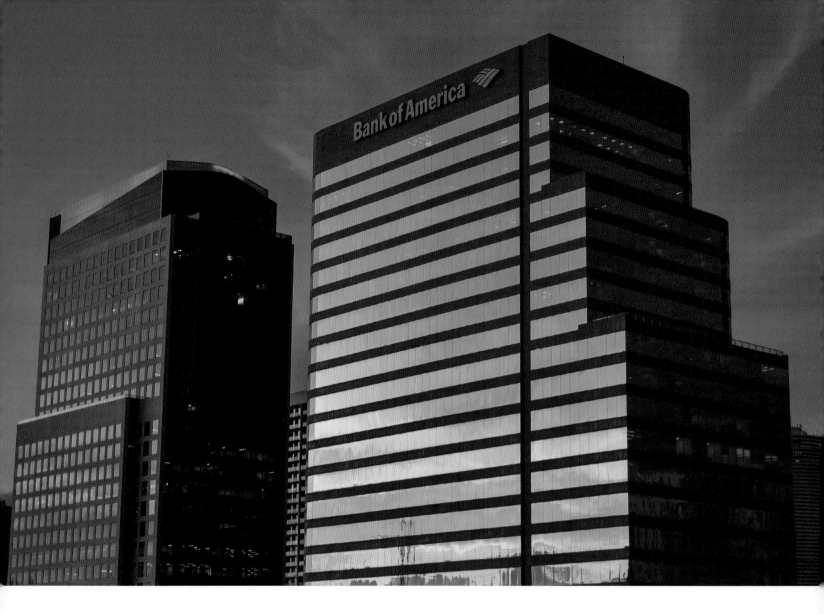

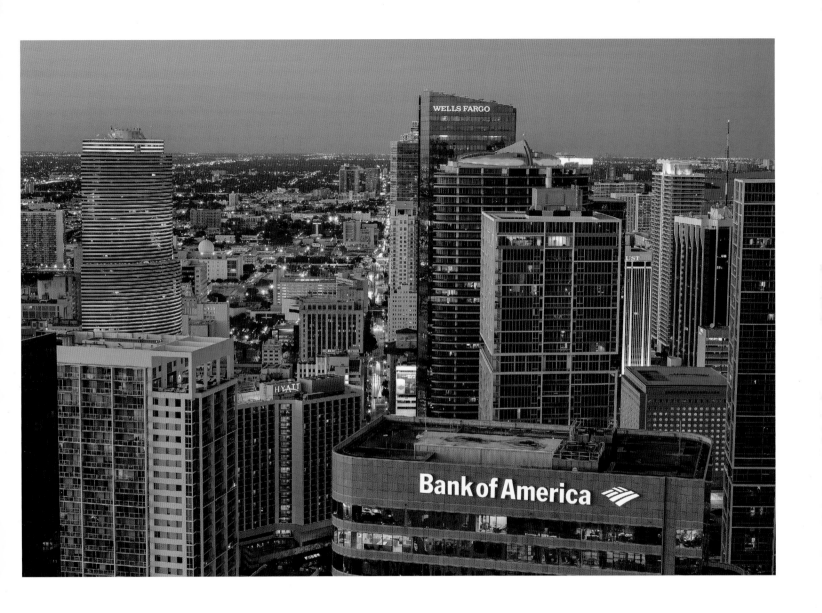

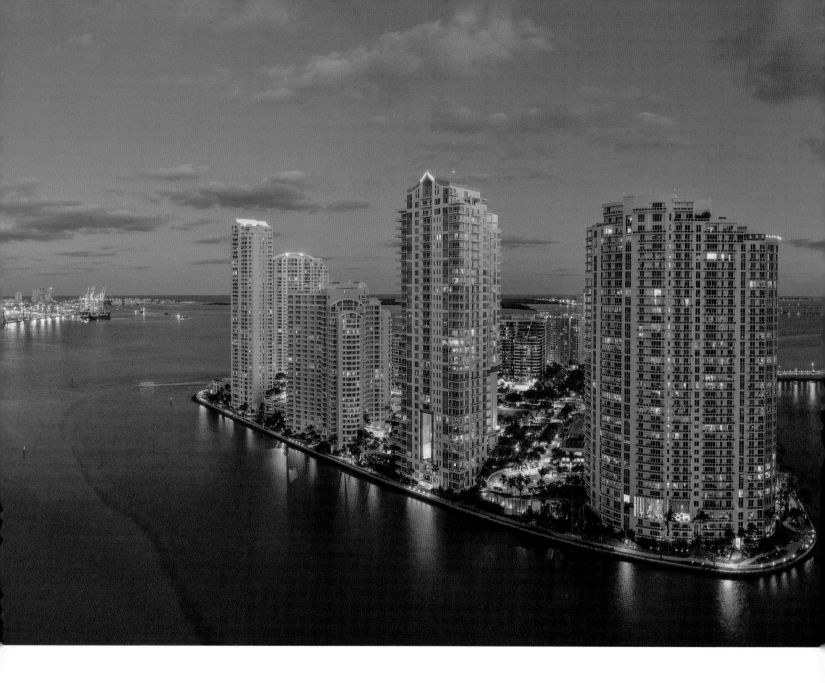

Colors light the skyline of Brickell Key and Brickell

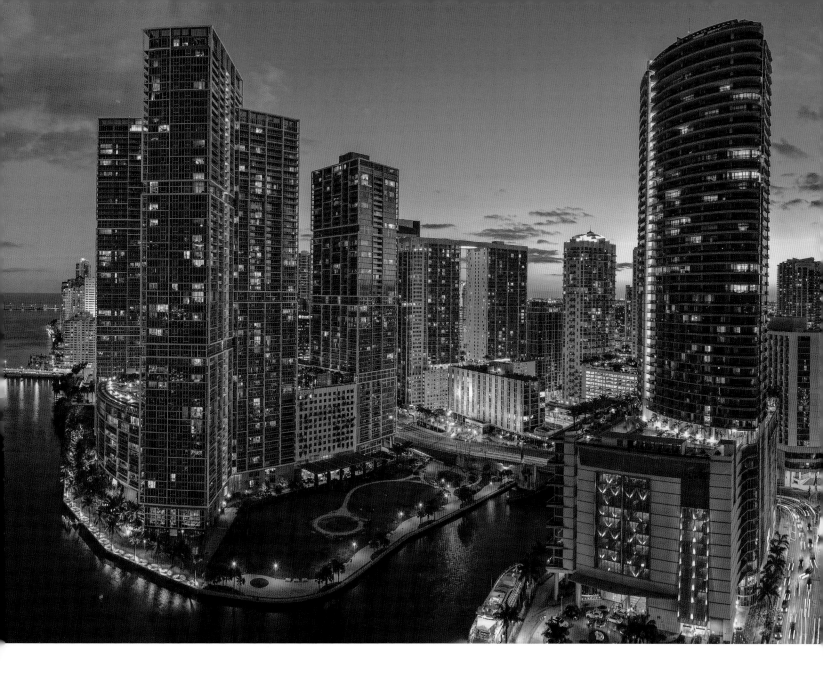

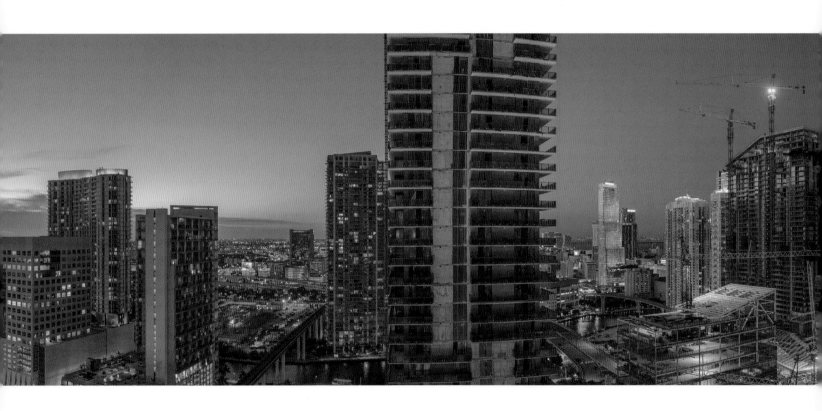

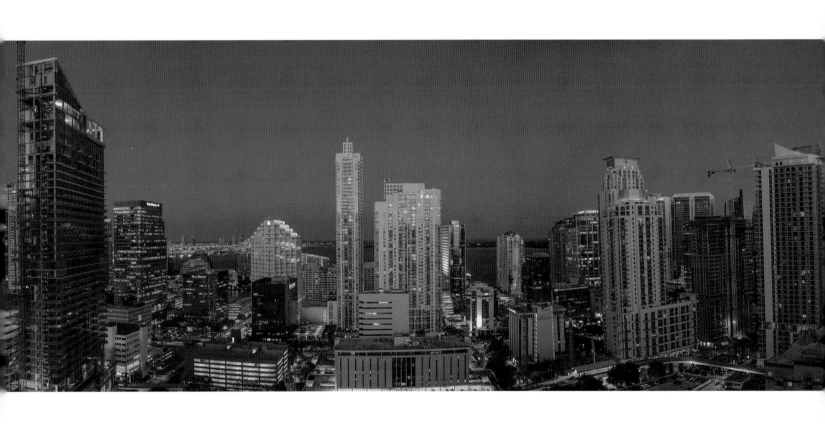

View of Brickell during the second construction boom of Miami in the last ten years

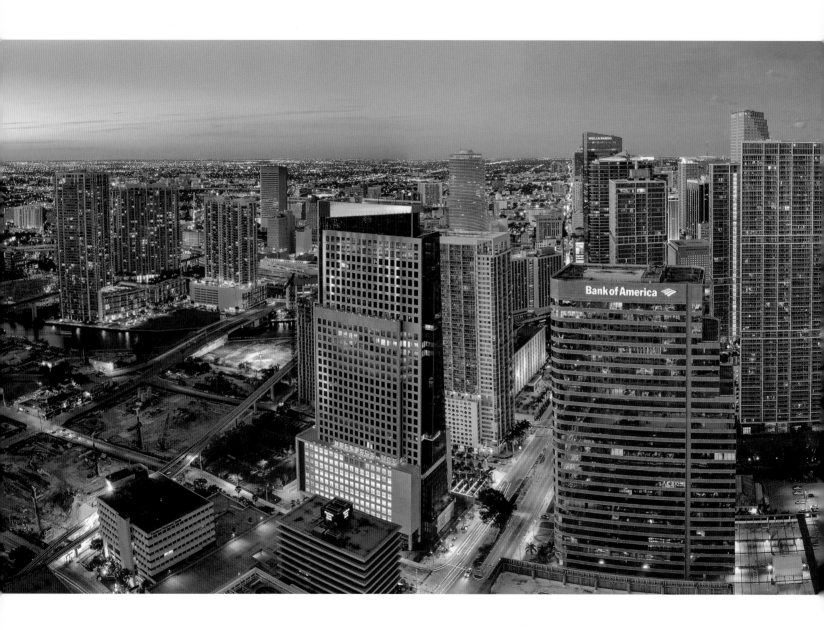

Overview of Brickell and Brickell Key, with South Beach in the background

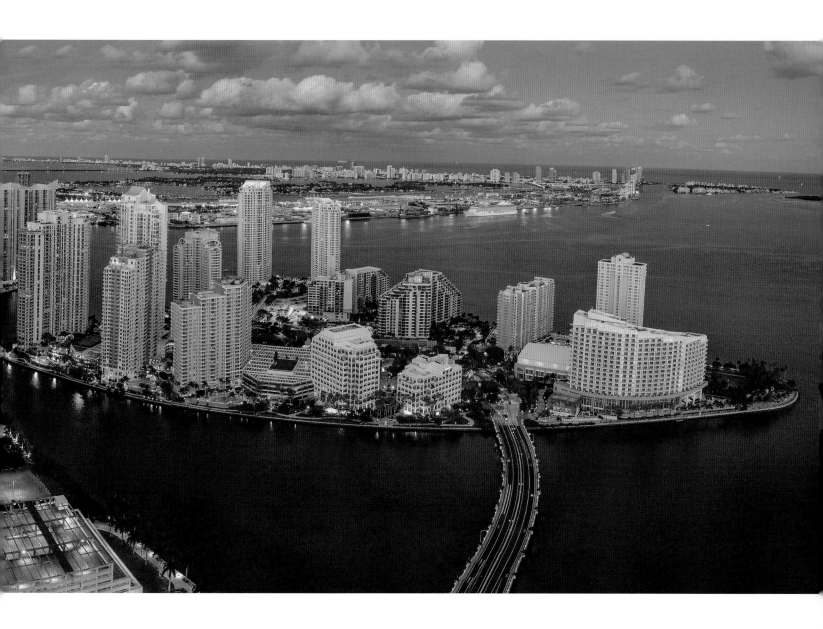

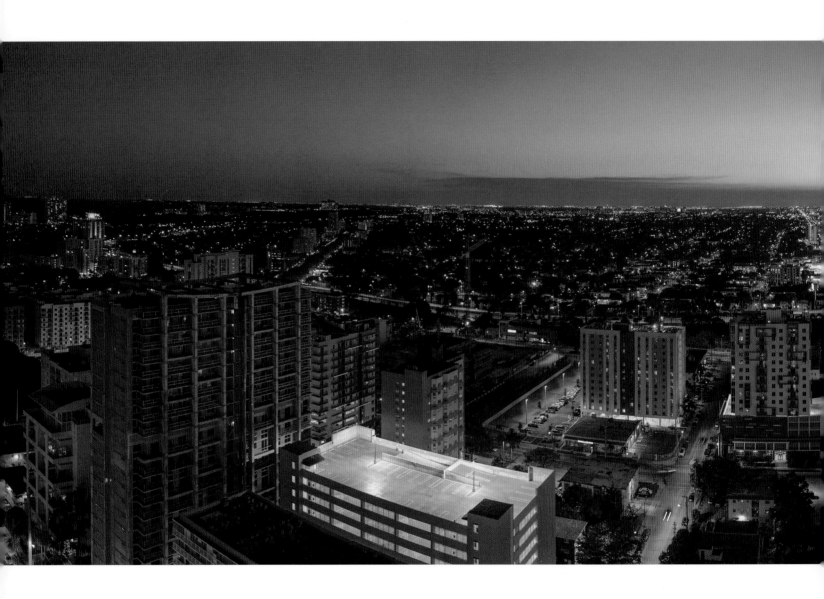

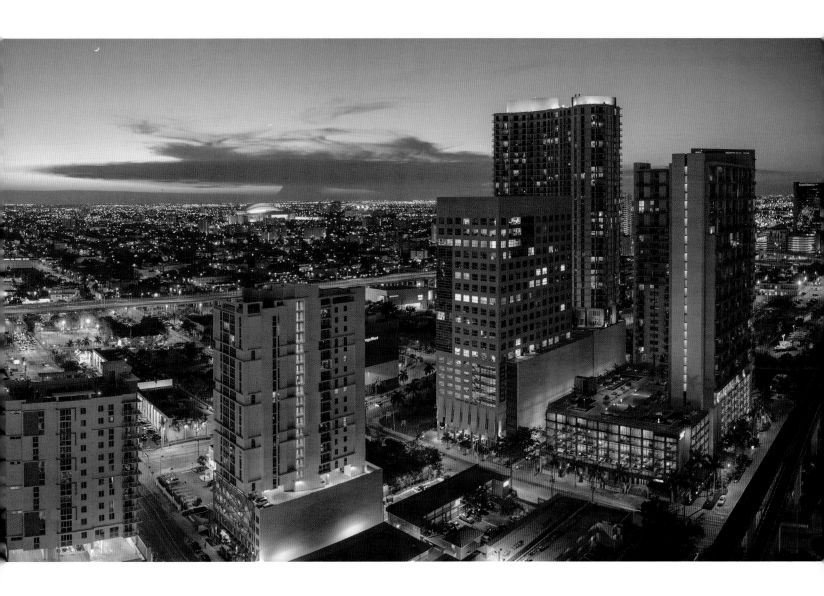

New developments are changing the look of West Brickell.

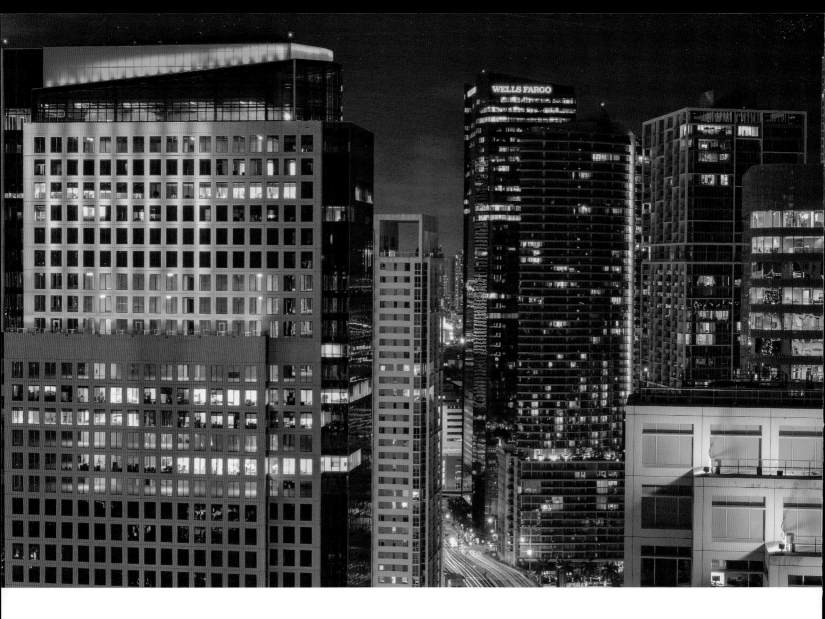

Condominiums and offices line Brickell Avenue.

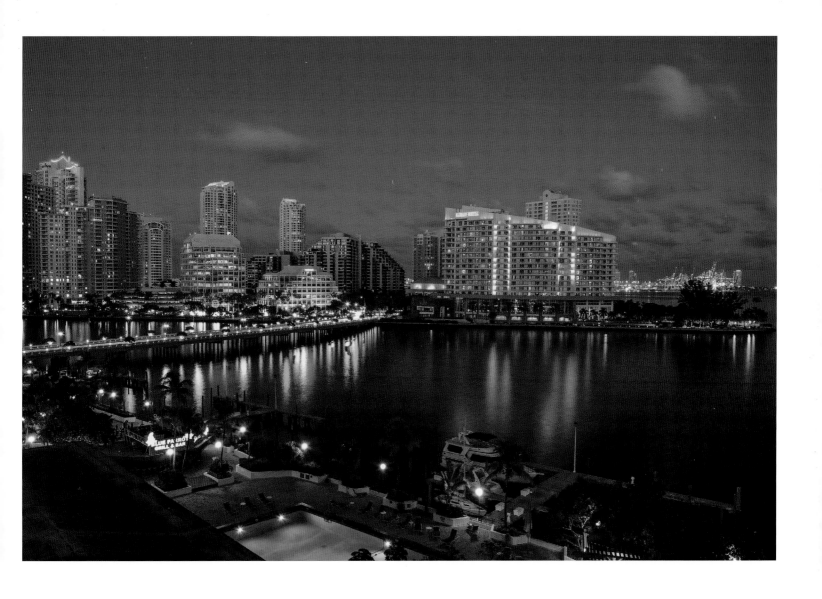

Brickell Key is home to the five-star Mandarin Oriental

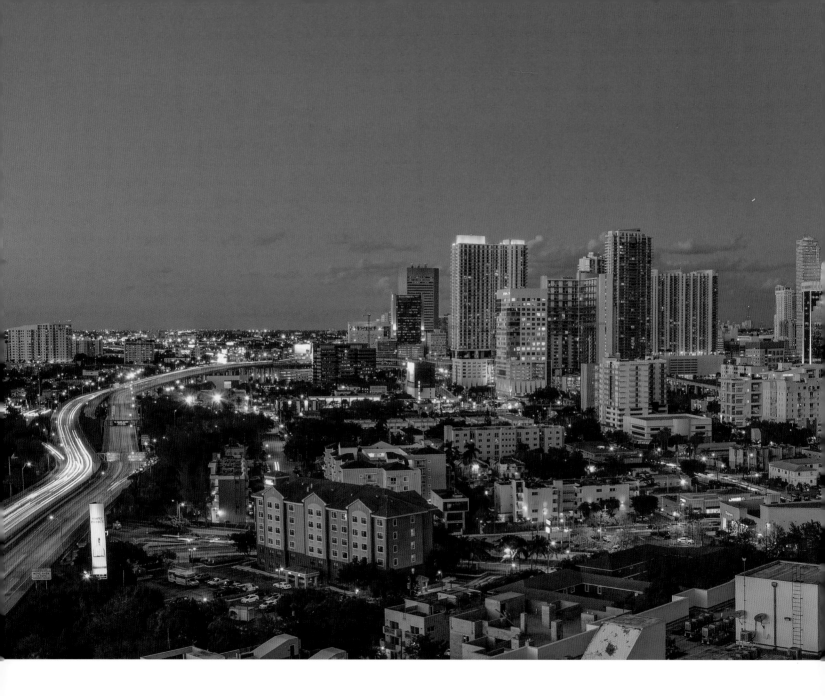

| Skyscrapers loom over Brickell, with I-95 on the left.

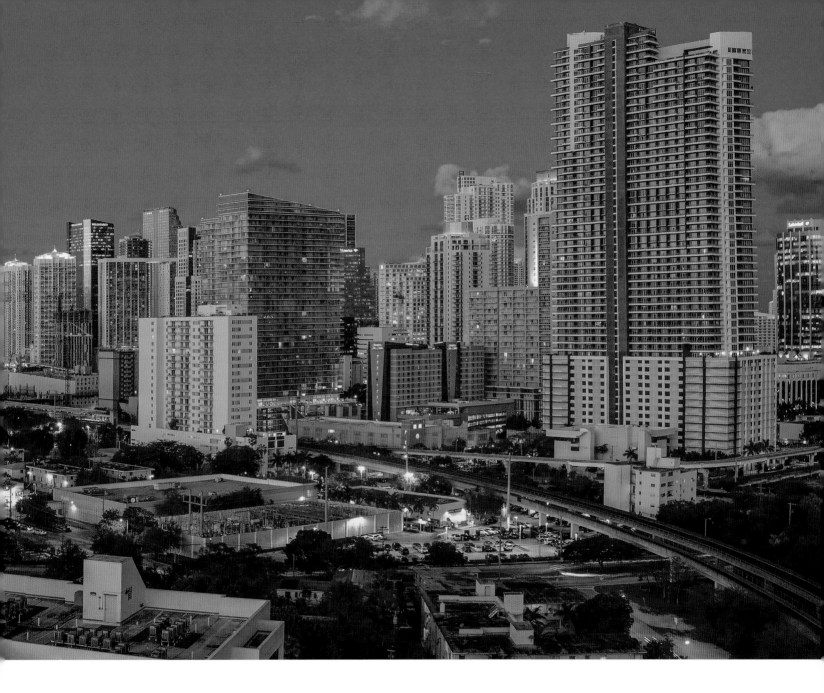

32 | Neon sign of Tobacco Road, once the oldest bar in Miami. The bar was demolished in November 2014.

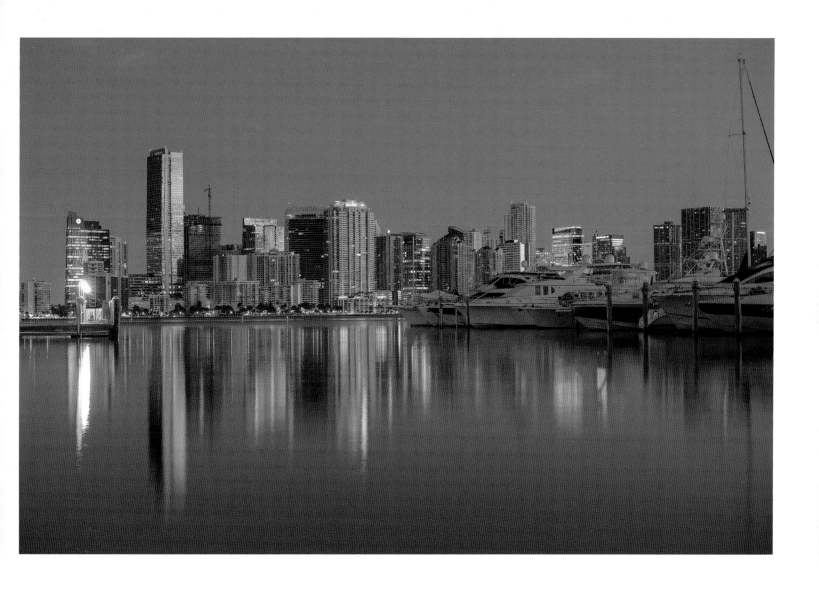

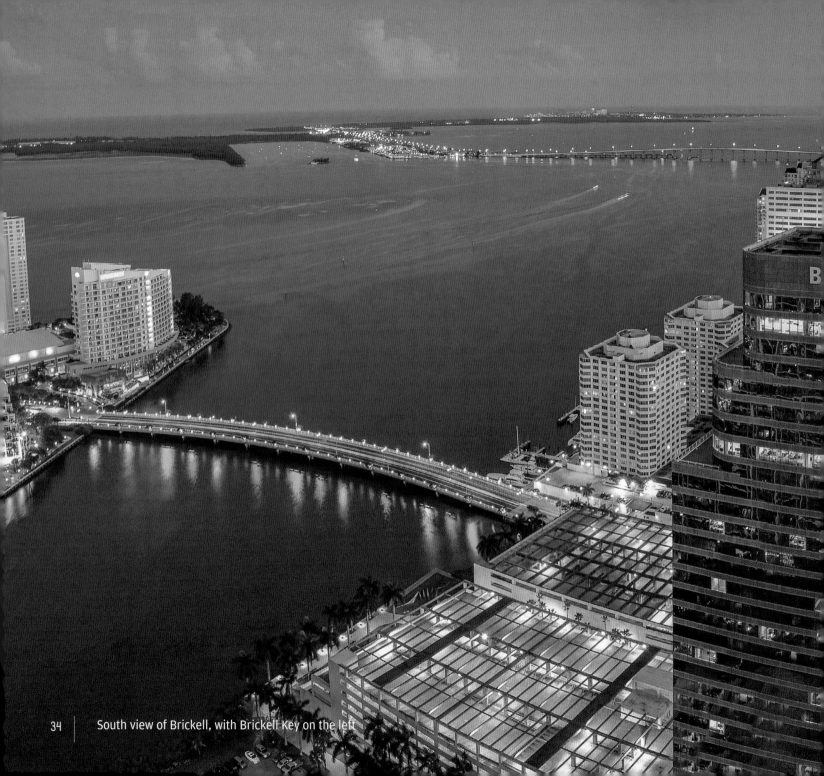

South view of Brickell, with Brickell Key on the left

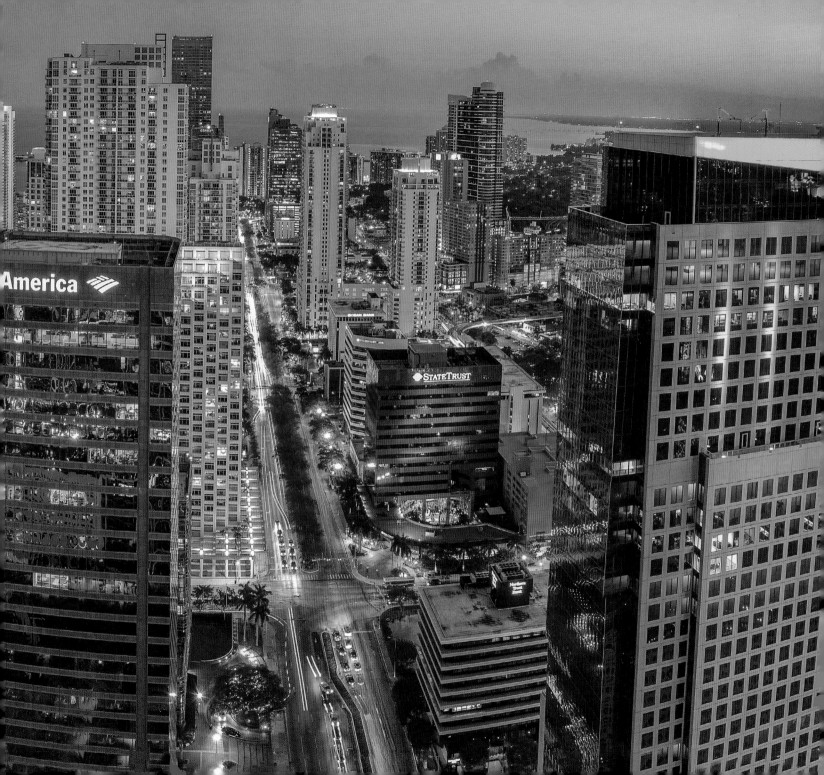

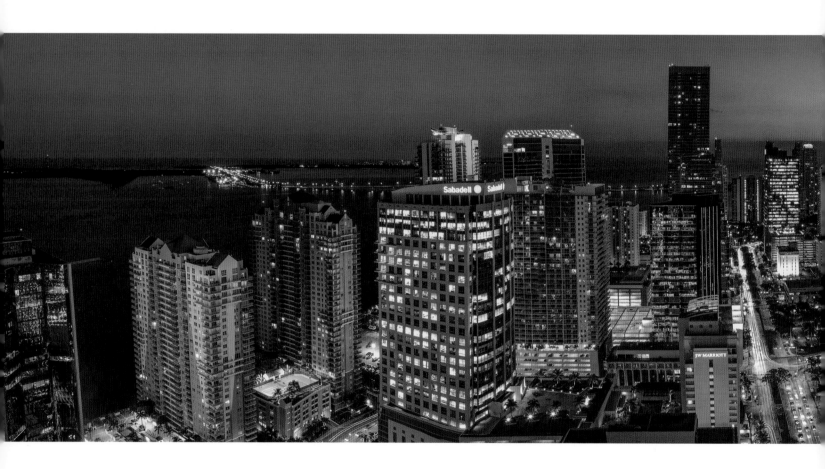

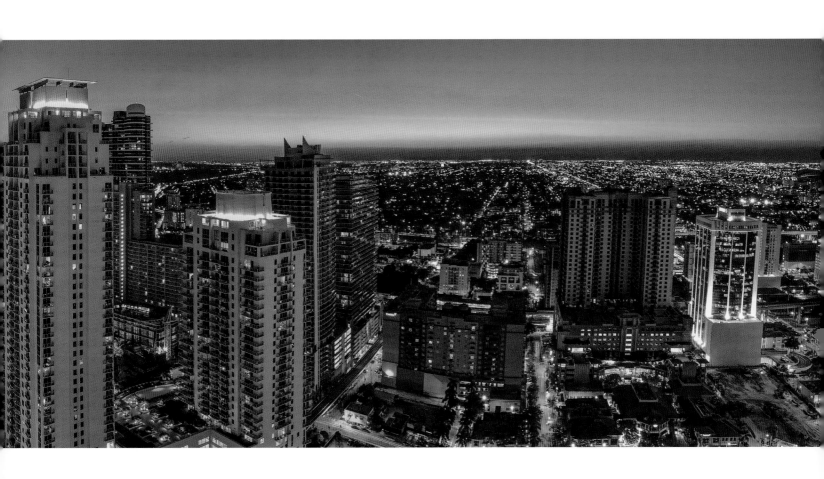

A colorful sunset glows over Brickell.

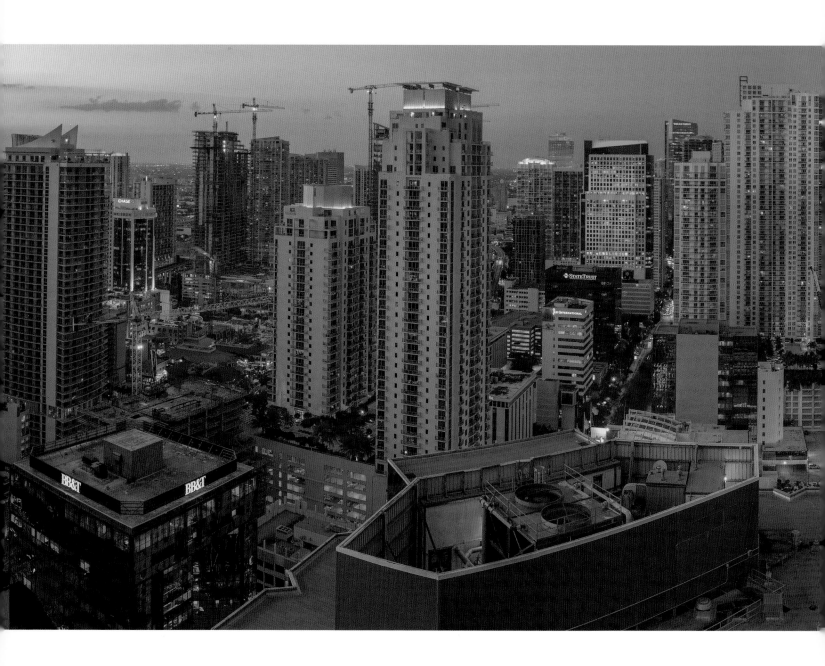

North view of Brickell overlooking Biscayne Bay

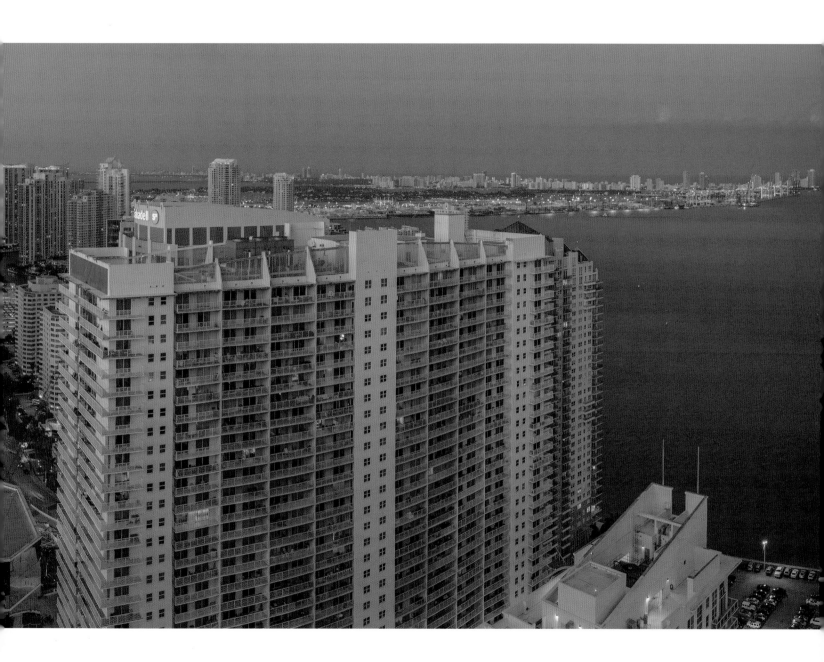

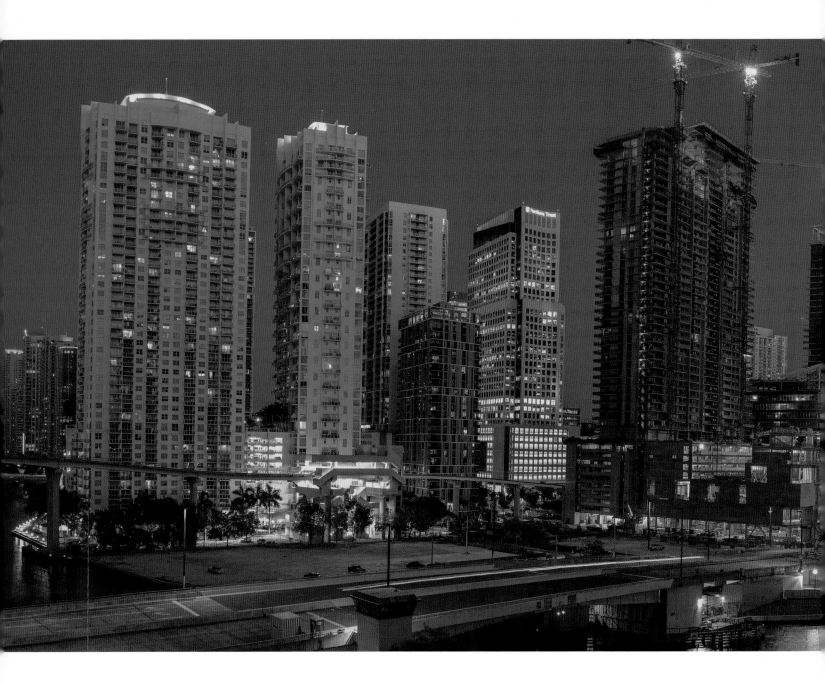

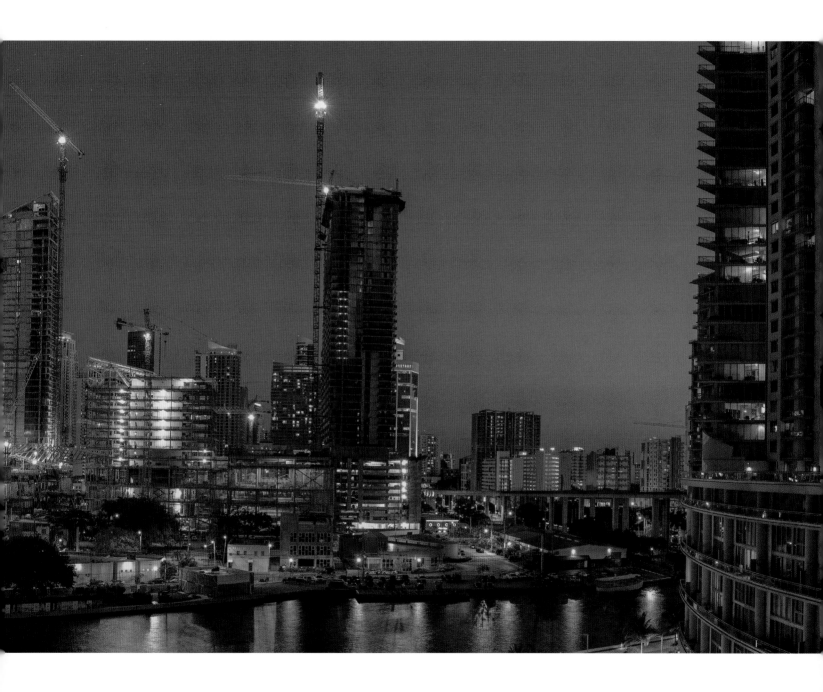

Construction on the $1.05 billion Brickell City Centre along the Miami River | 41

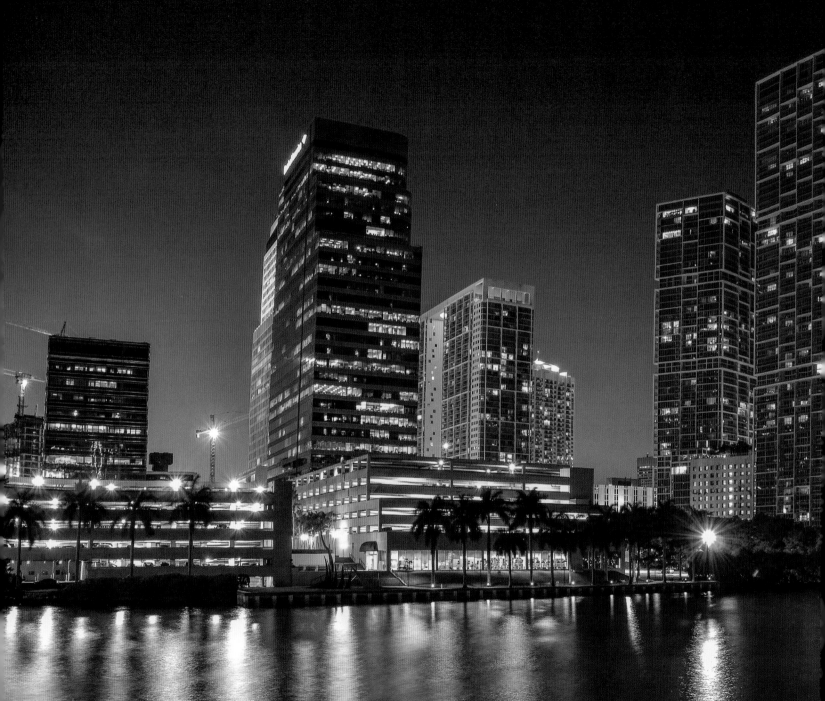

The large high rises of Brickell and Brickell Key

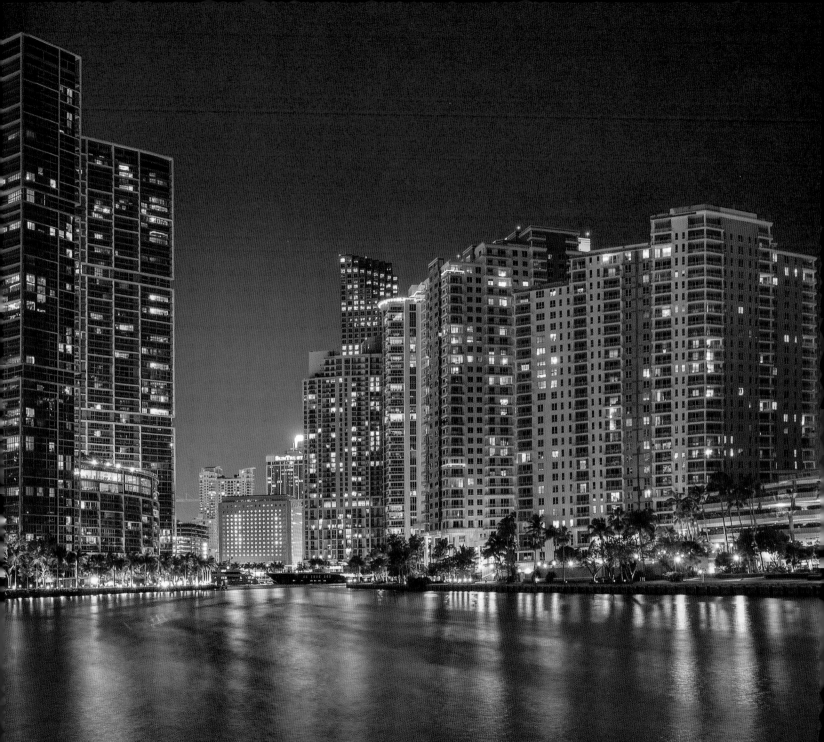

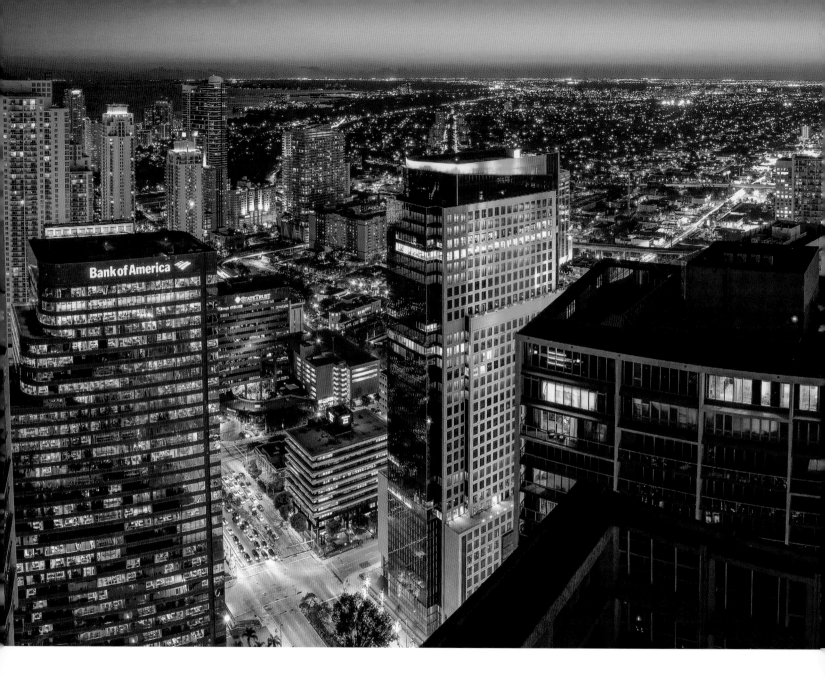

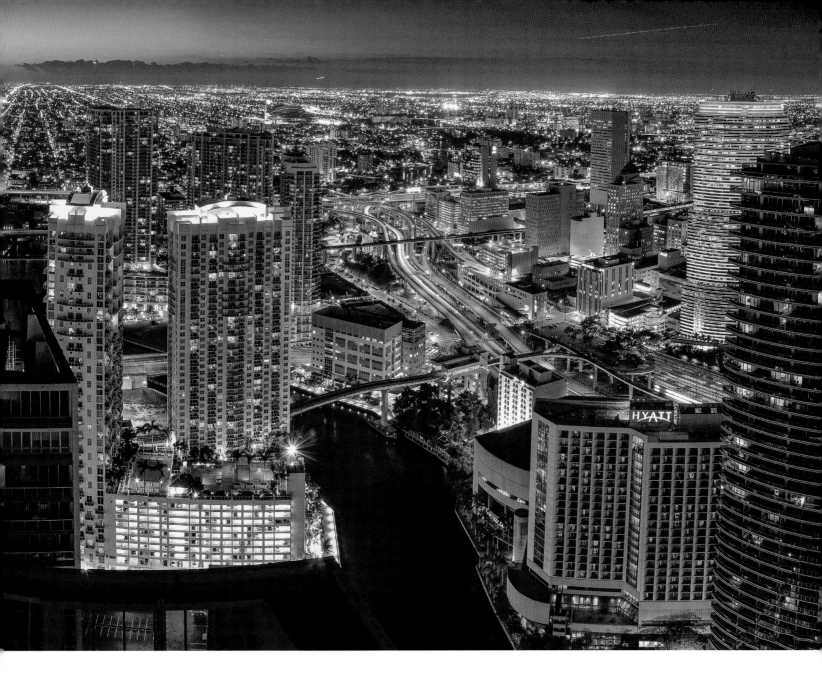

The view of Miami at night captures the essence of the city.

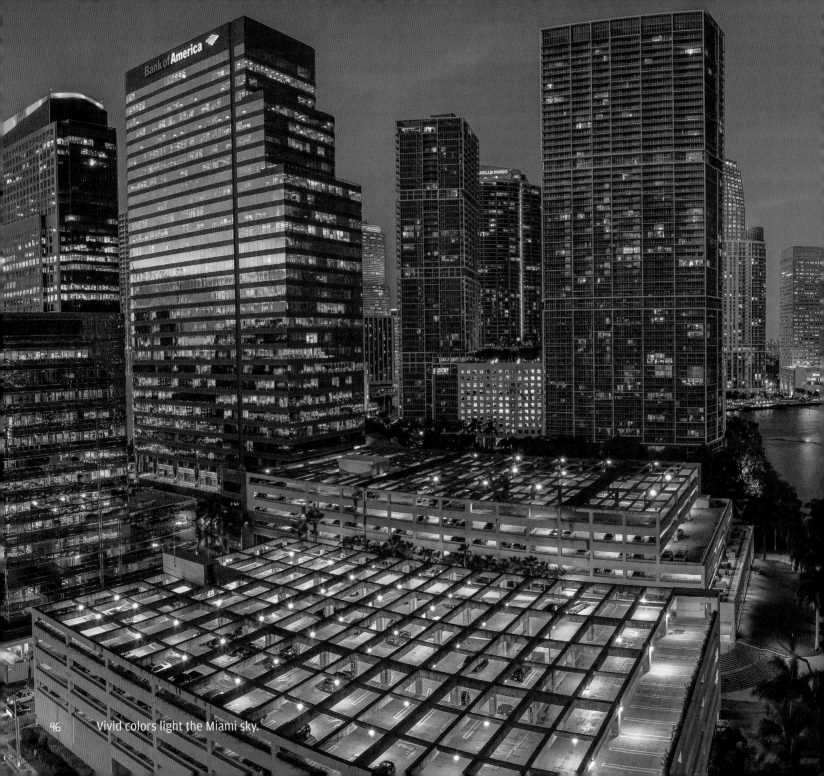

Vivid colors light the Miami sky.

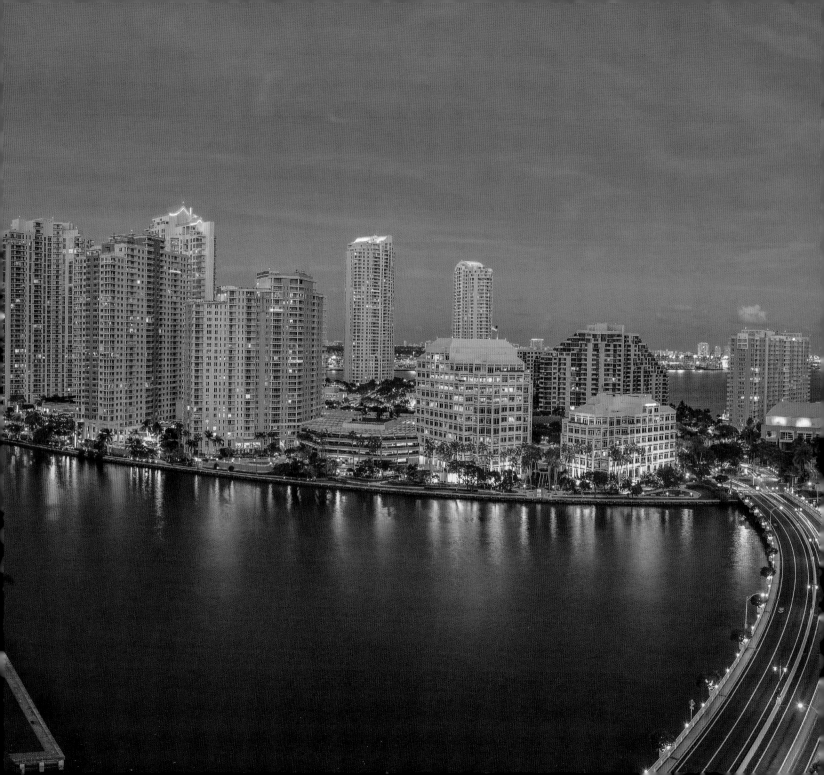

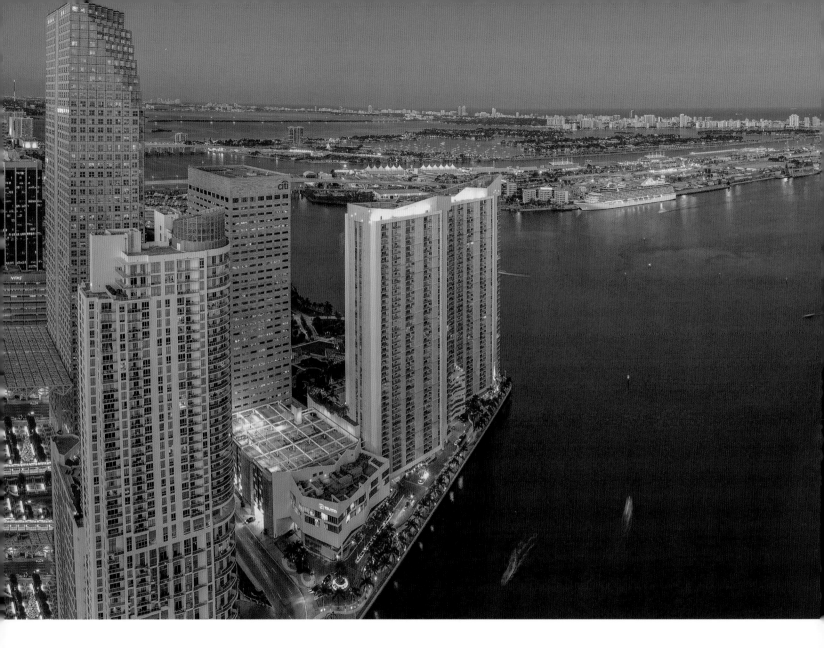

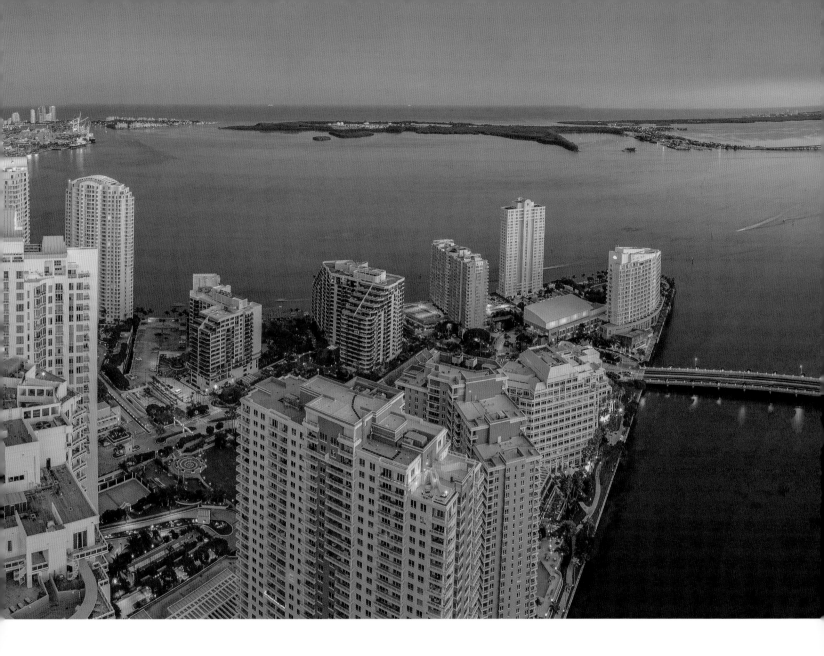

Entrance to the Miami River from Biscayne Bay | 49

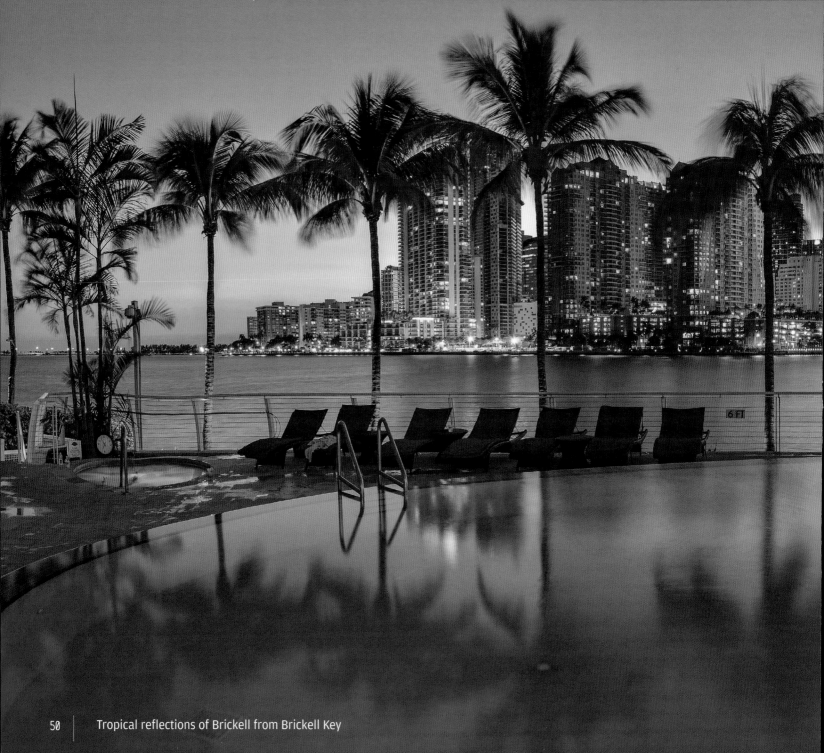

| Tropical reflections of Brickell from Brickell Key

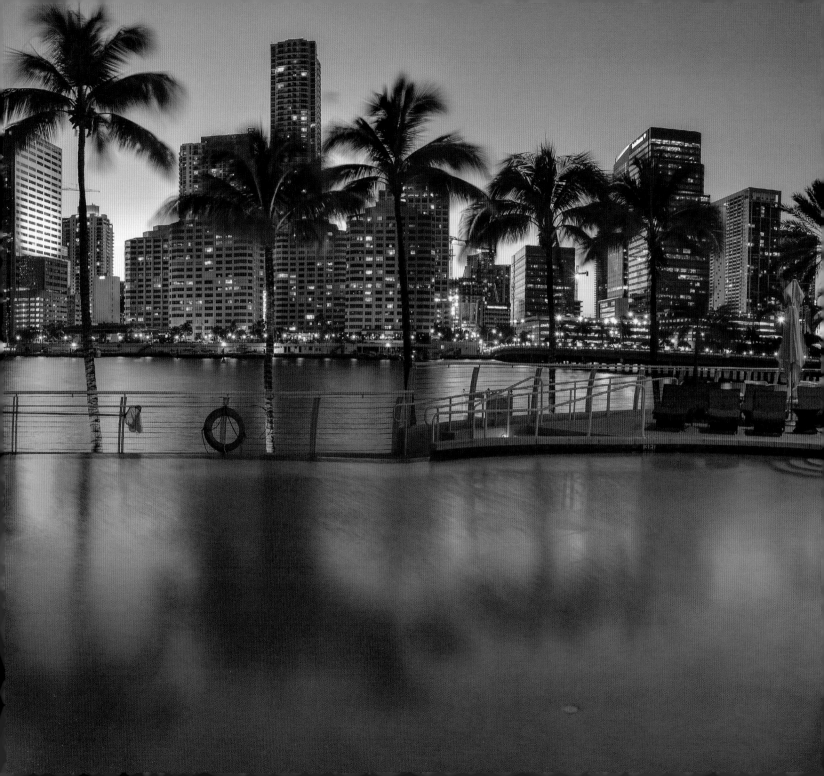

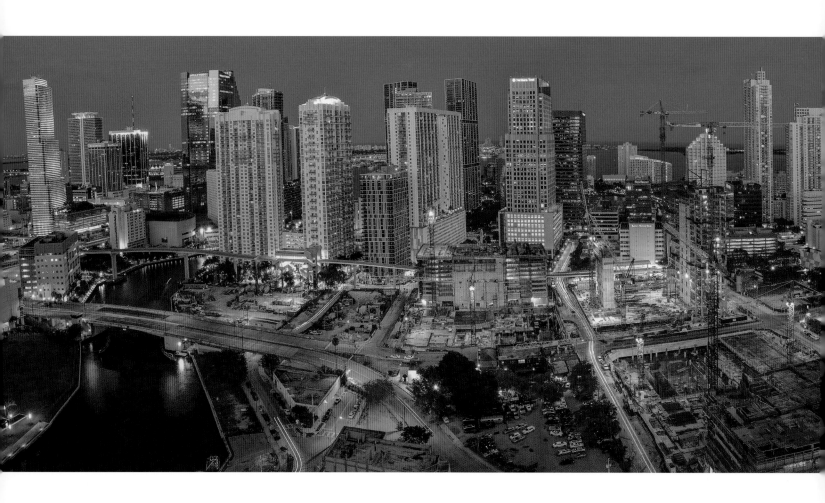

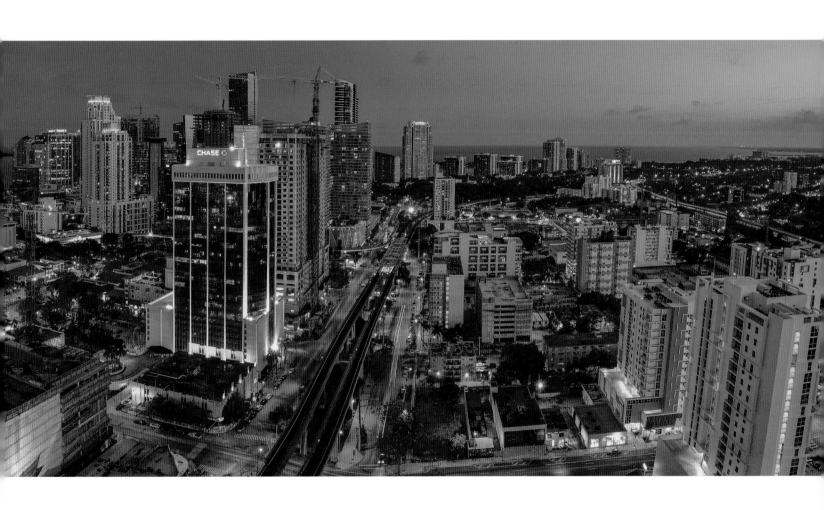

Southeast view of Brickell and the construction of Brickell City Centre | 53

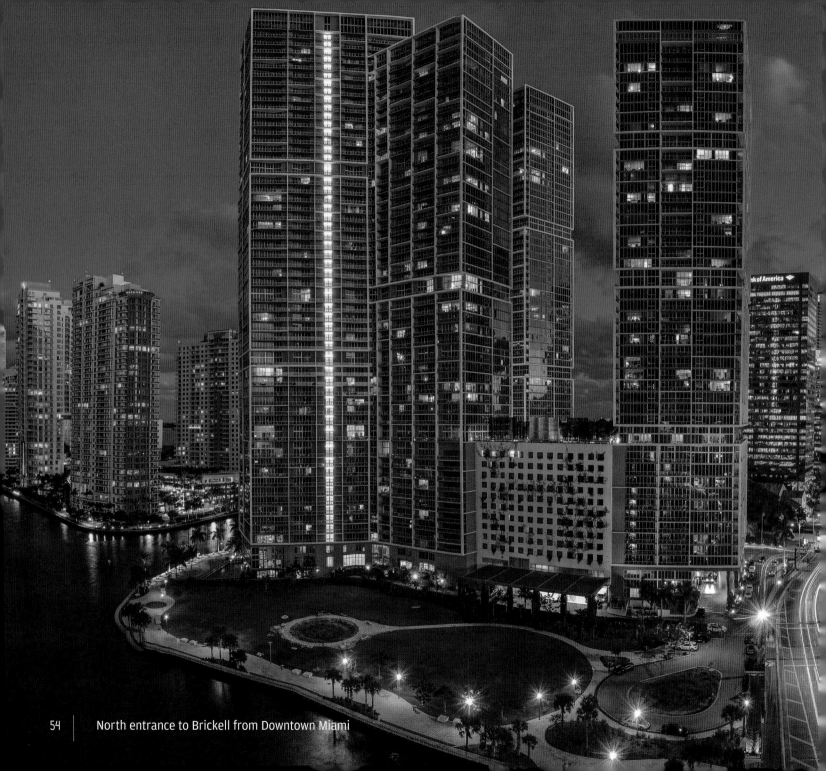

North entrance to Brickell from Downtown Miami

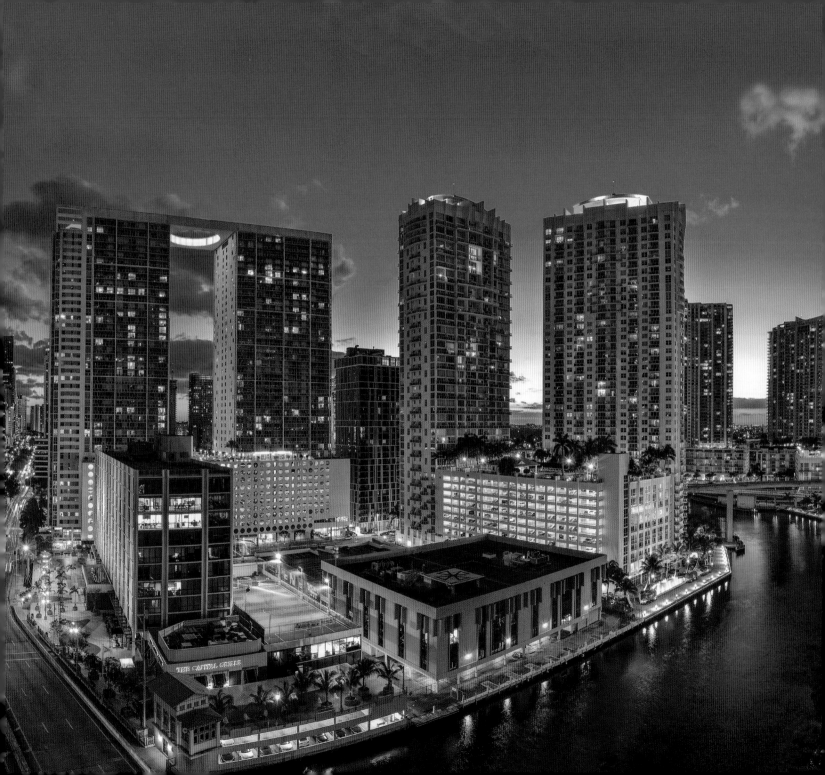

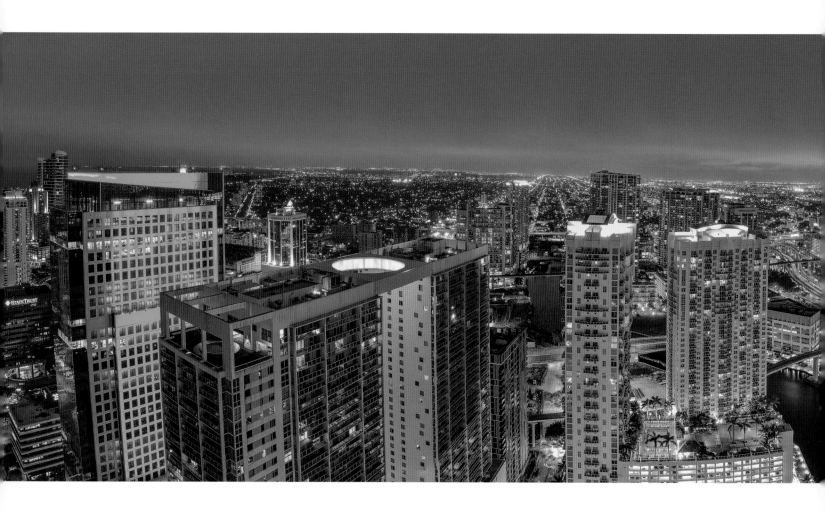

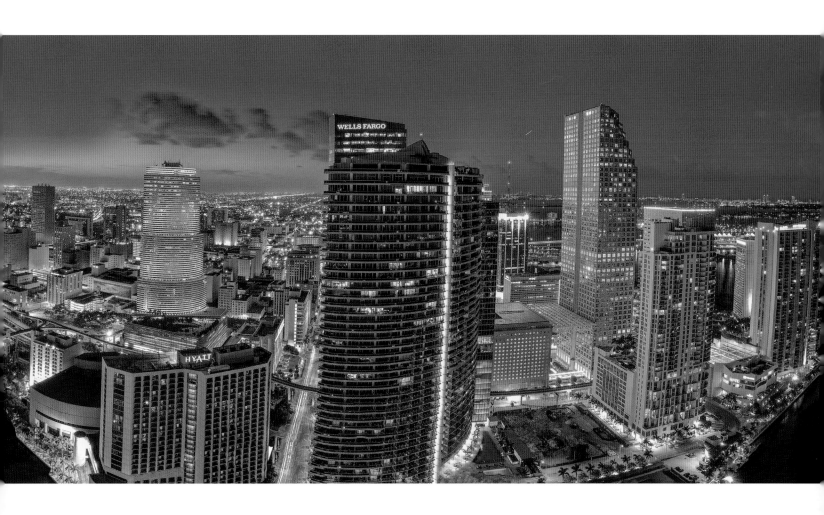

Panoramic view of Downtown Miami and Brickell over the Miami River

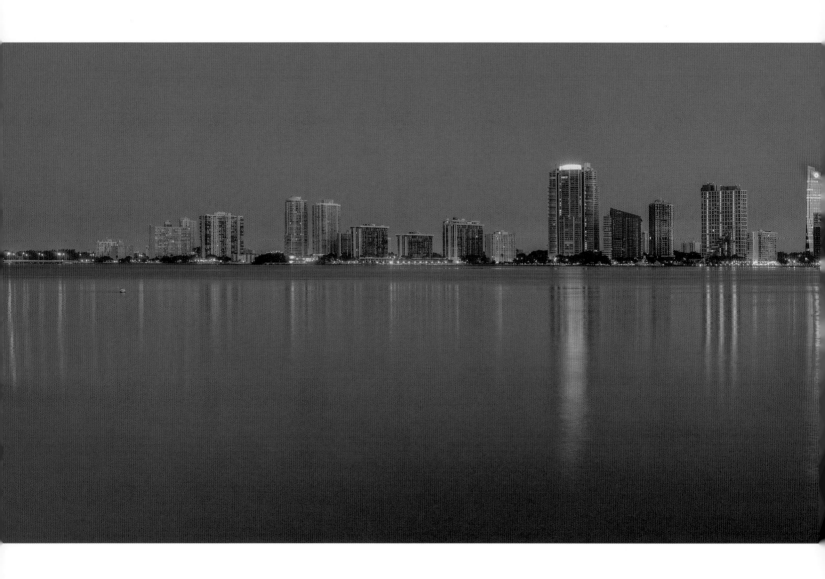

The glowing lights of Brickell off Biscayne Bay

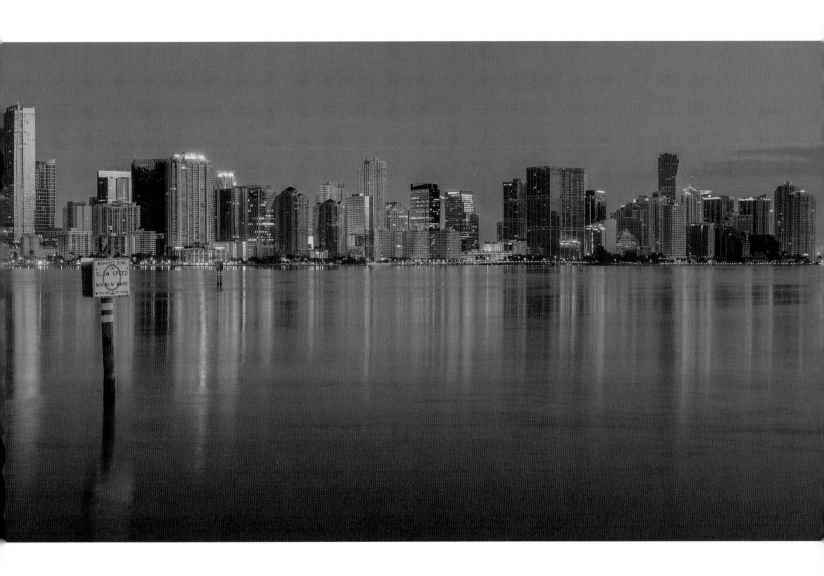

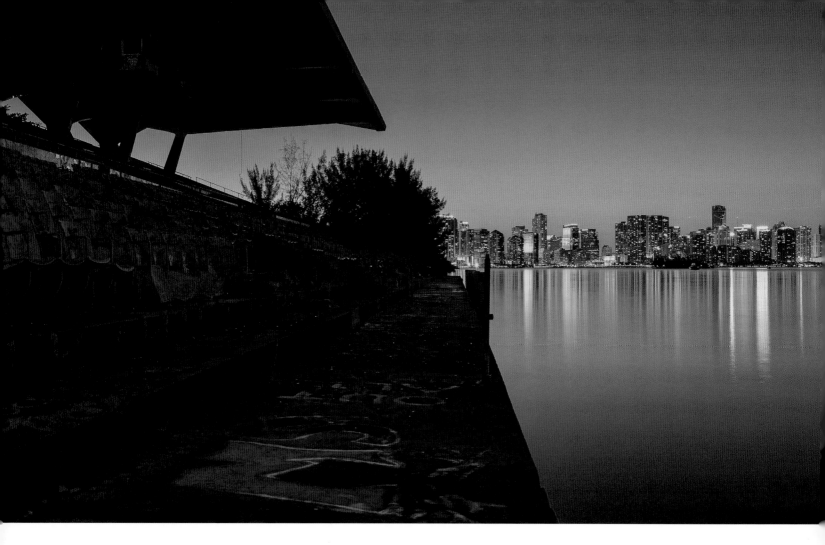

PART 2 KEY BISCAYNE, CORAL GABLES, AND COCONUT GROVE

| Miami Marine Stadium has been abandoned since 1992, after Hurricane Andrew.

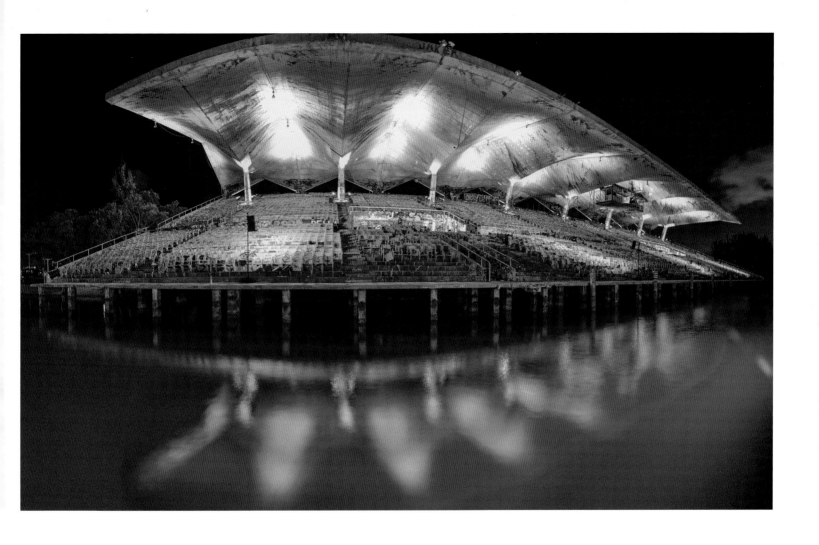

Miami Marine Stadium lights up for a special Art Basel event in 2013.

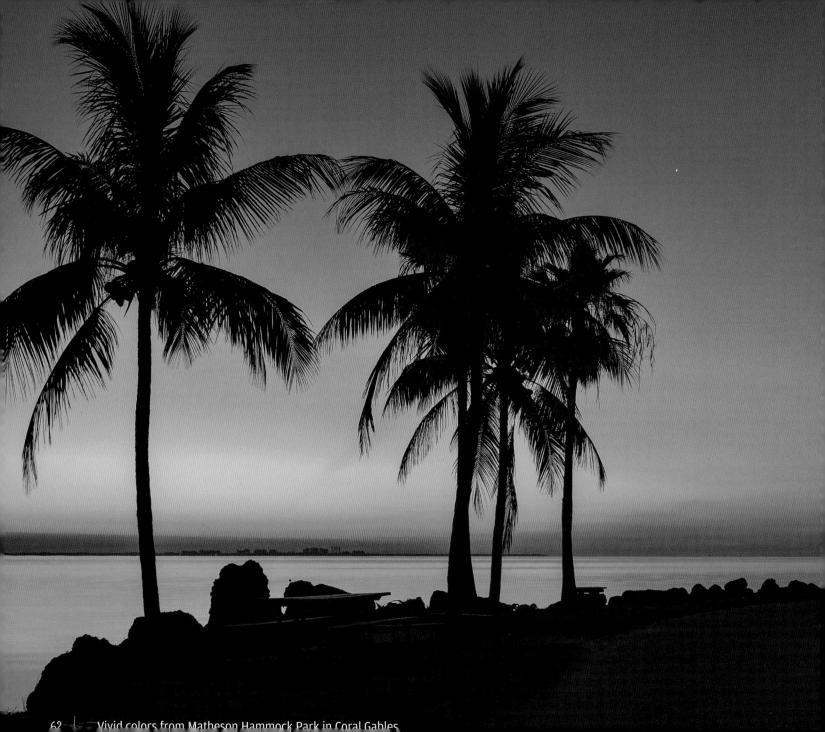

Vivid colors from Matheson Hammock Park in Coral Gables

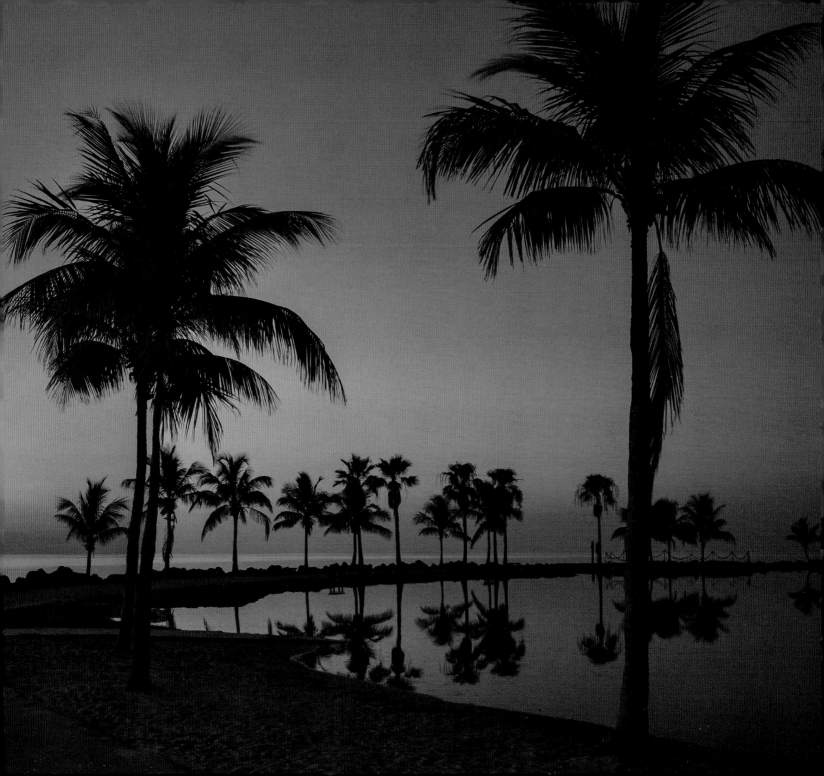

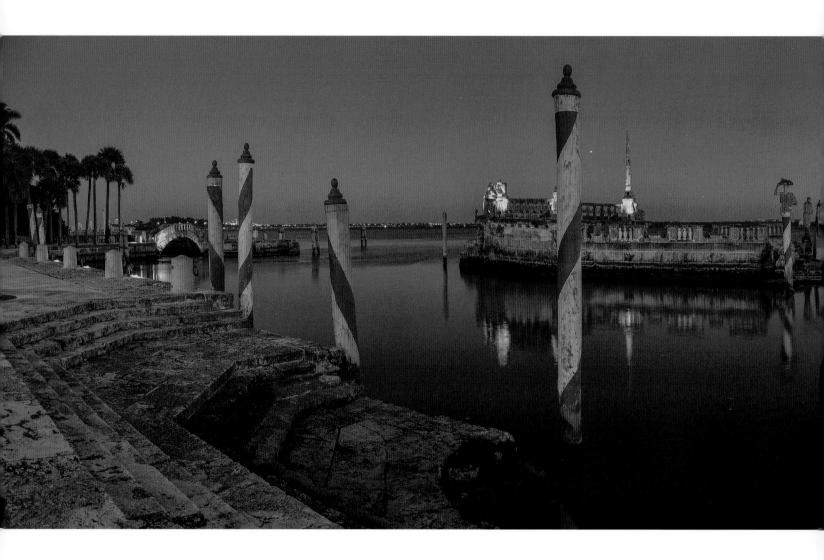

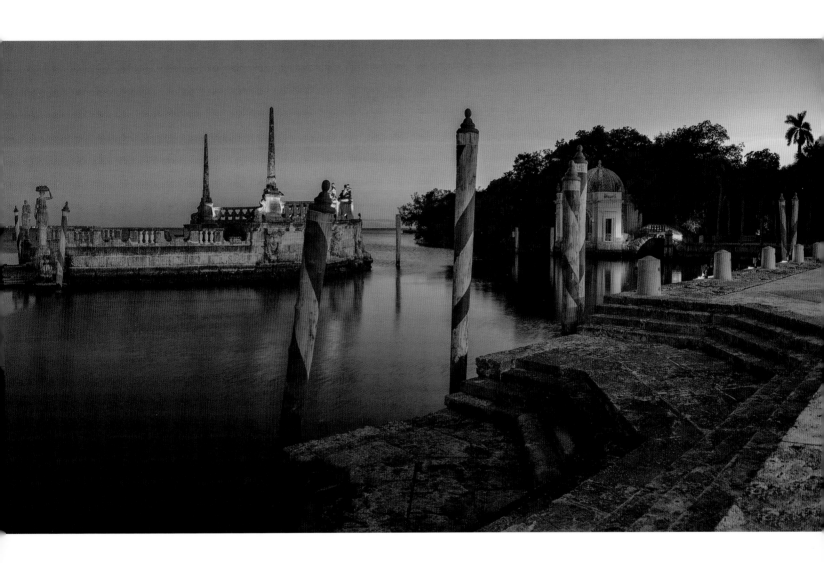

View from Vizcaya, a historical landmark in Coconut Grove | 65

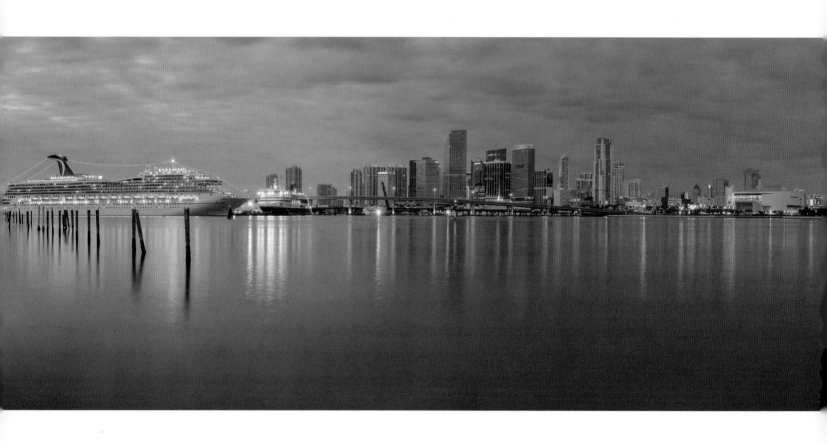

PART 3 DOWNTOWN MIAMI

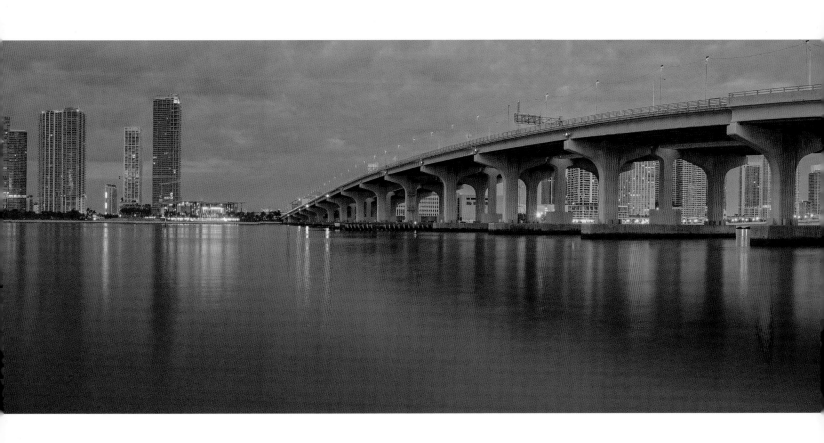

An iconic view of Downtown Miami from Watson Island

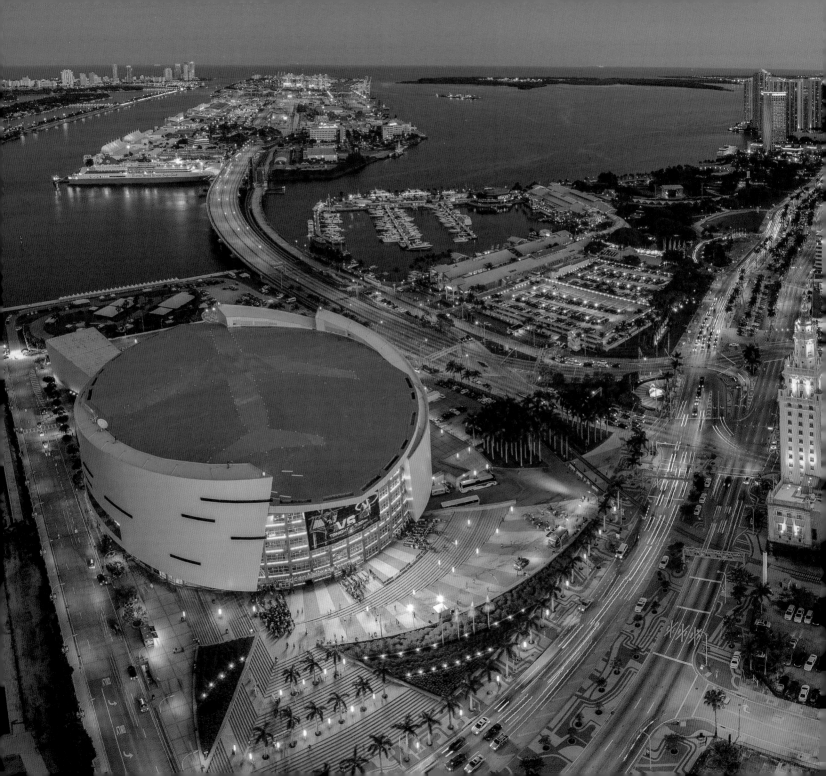

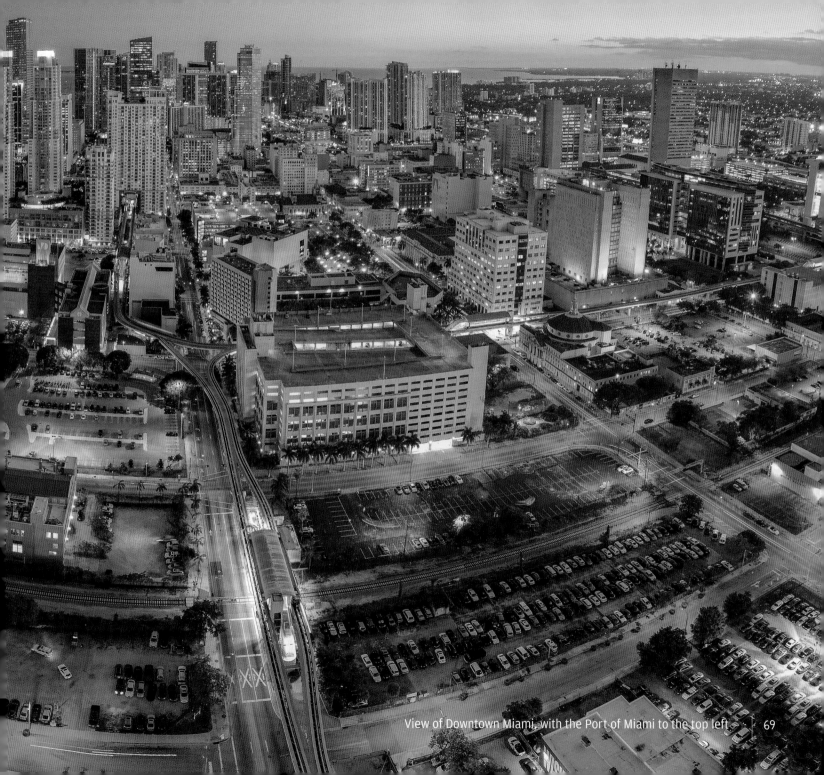

View of Downtown Miami, with the Port of Miami to the top left | 69

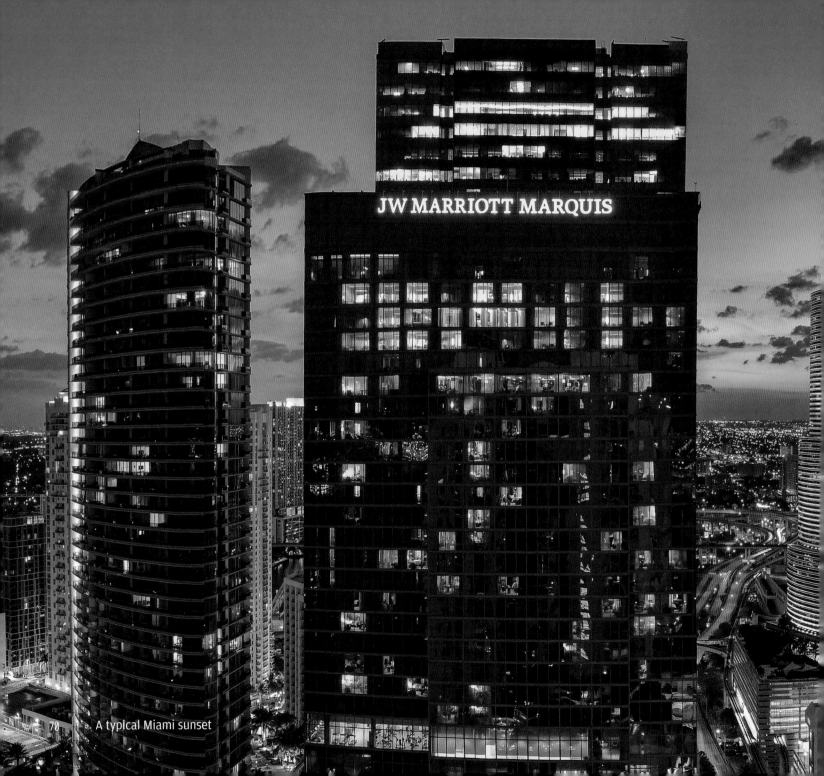

JW MARRIOTT MARQUIS

A typical Miami sunset

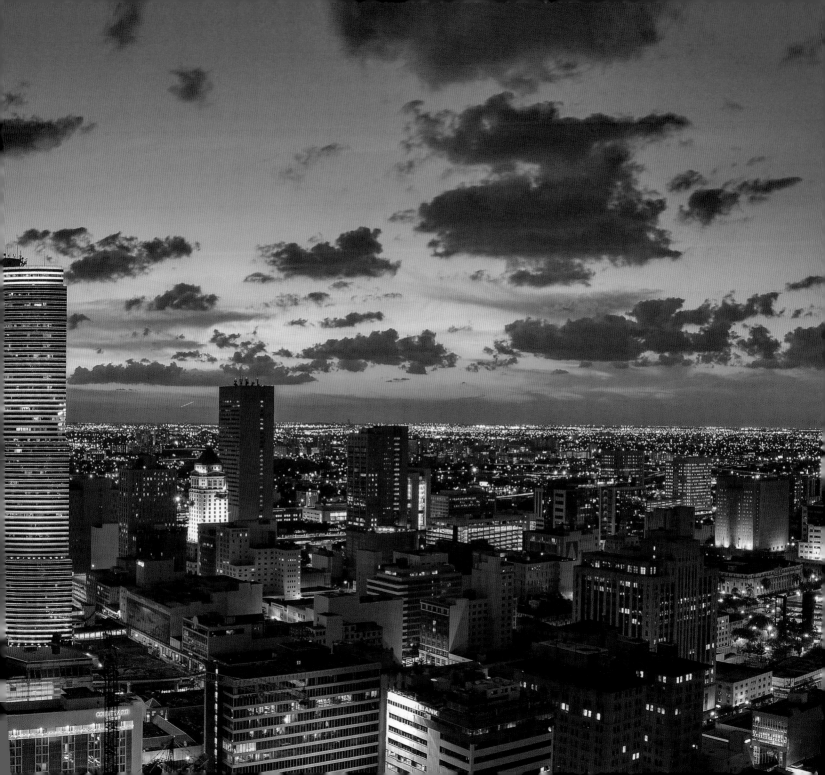

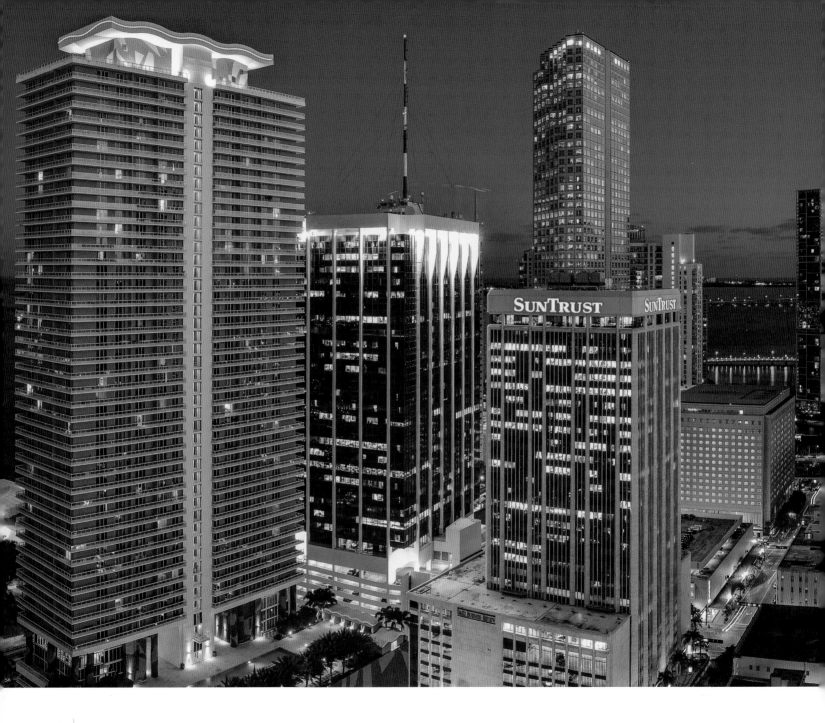

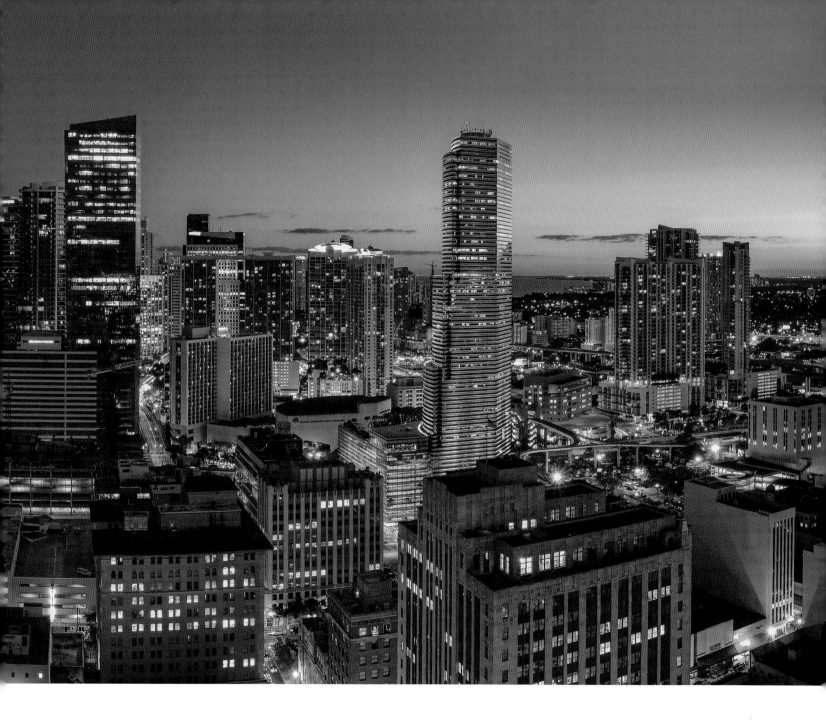

South view of Downtown Miami |

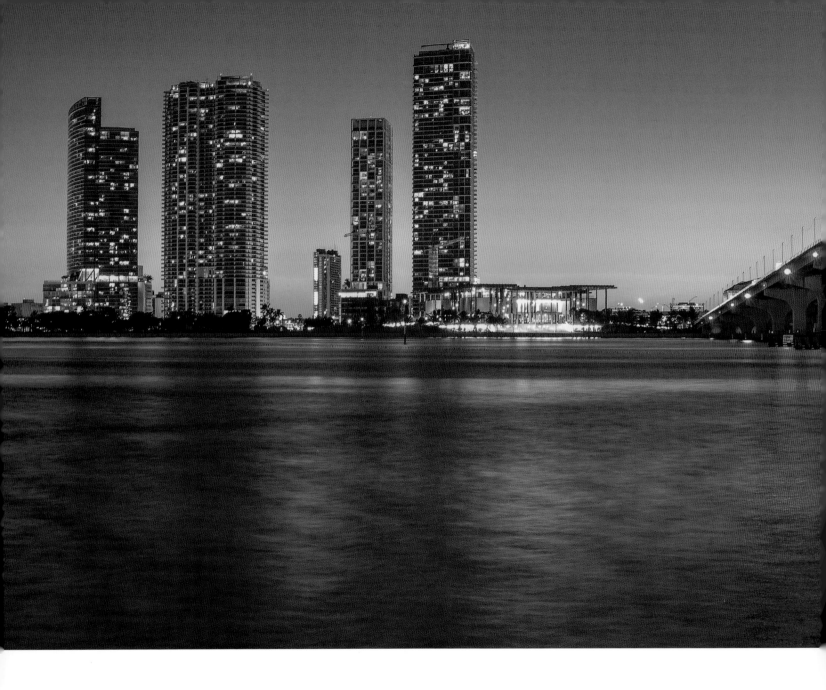

| The pink bridge of the MacArthur Causeway, which leads into South Beach

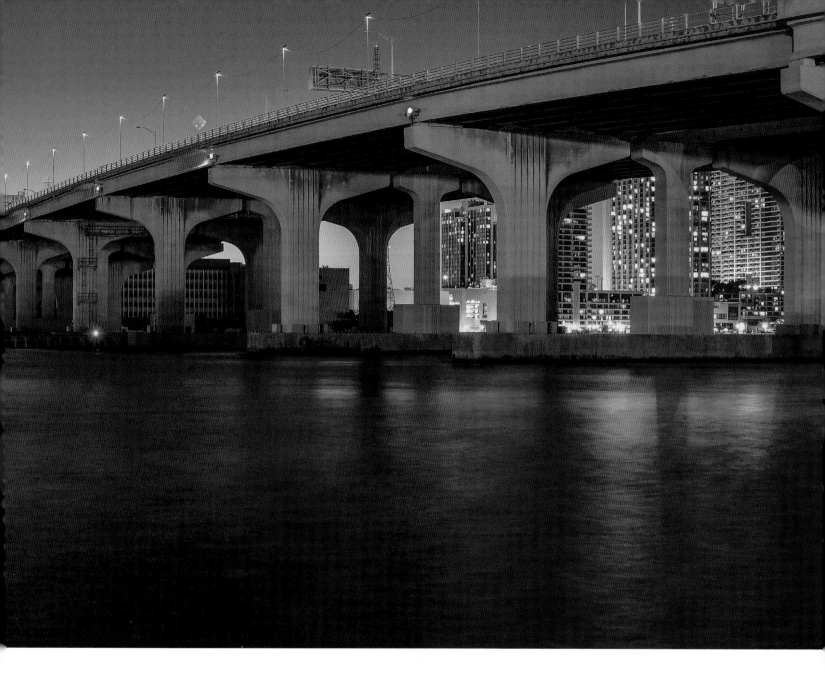

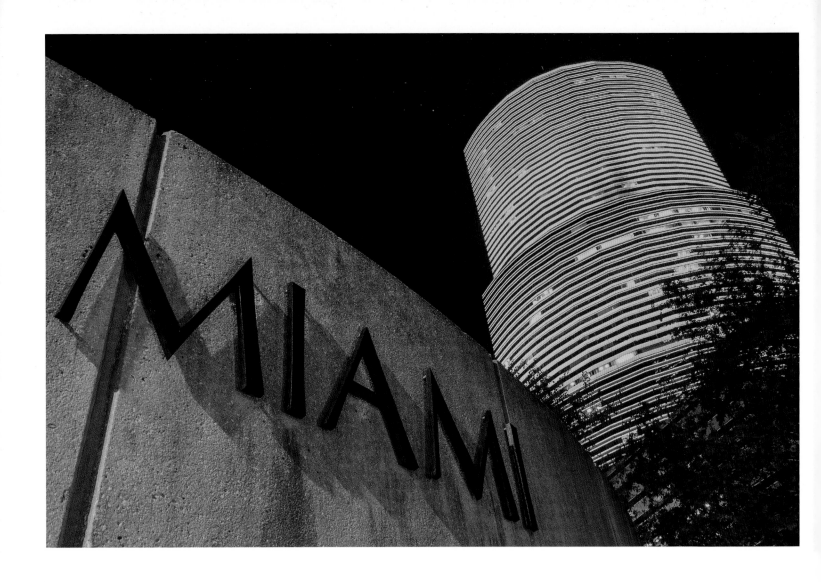

The Miami Tower high above the city

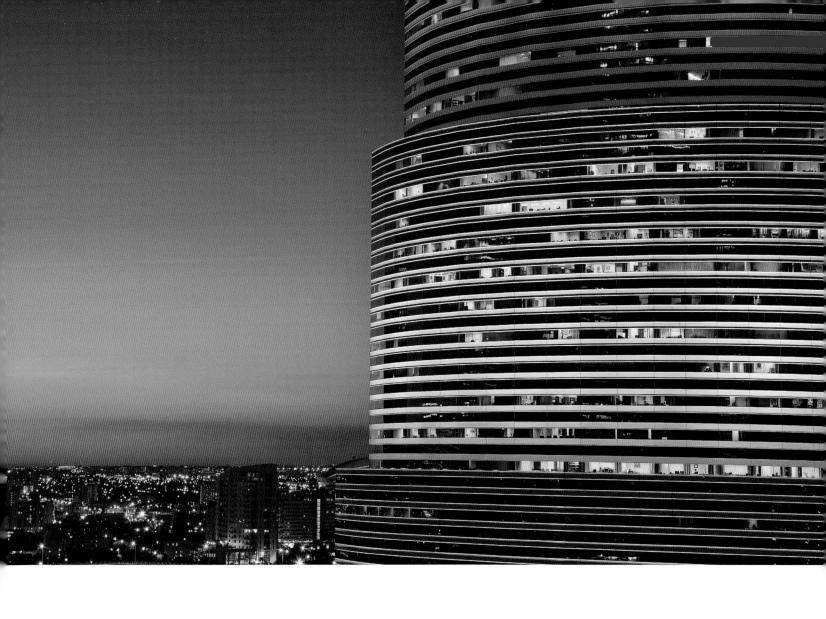

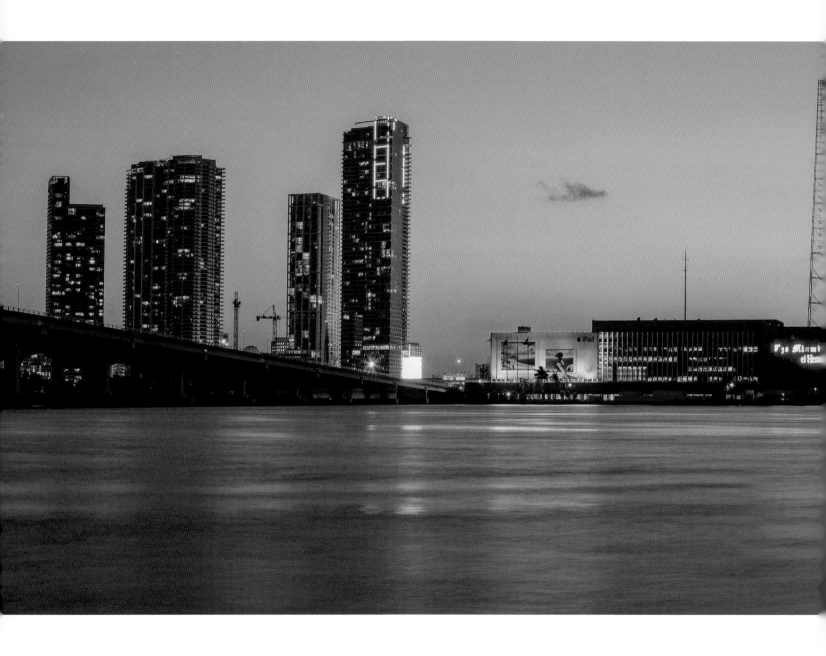

| *The Miami Herald* building before being demolished in early 2015

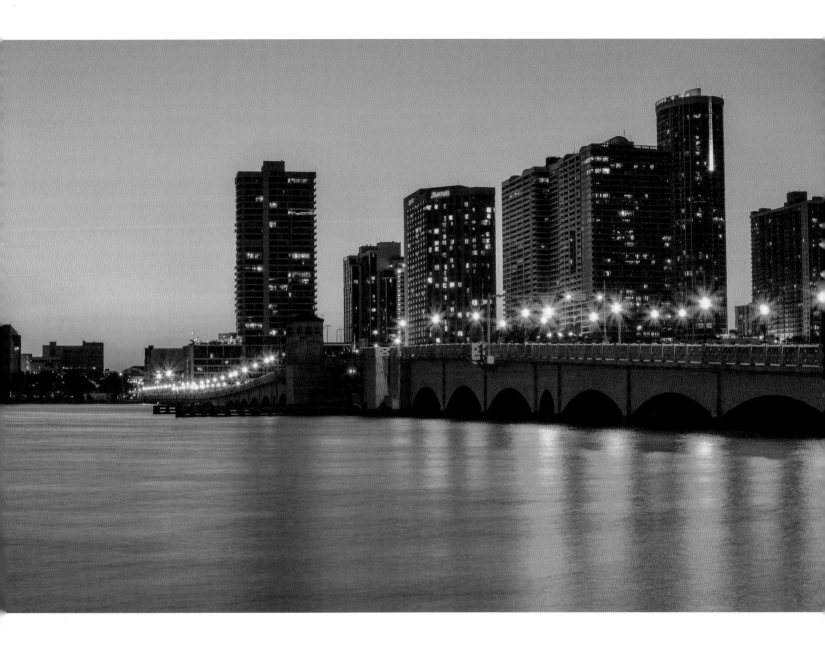

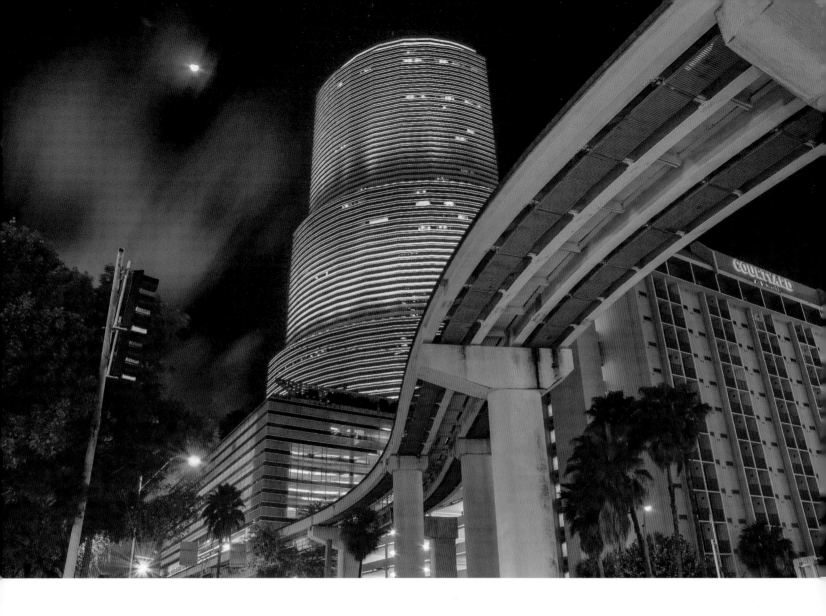

The Miami Tower above Biscayne Boulevard

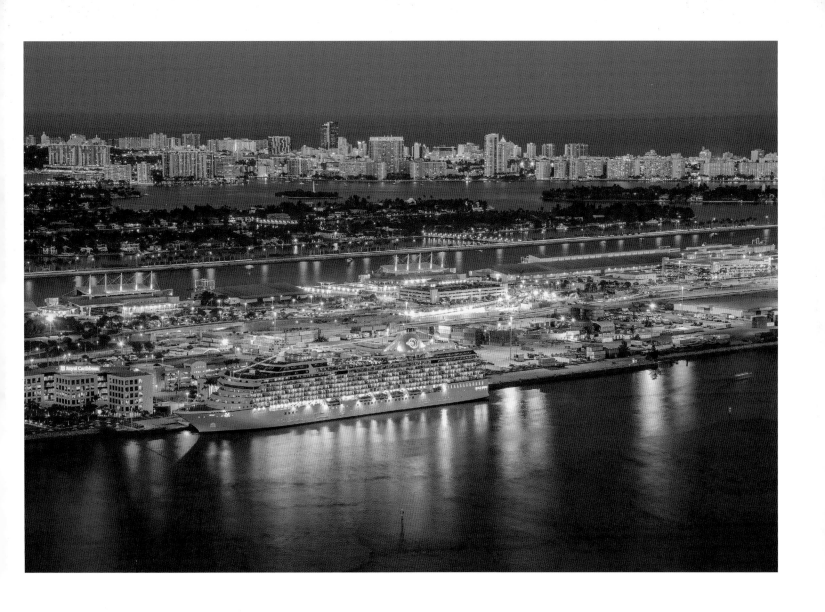

View of the Port of Miami, the cruise ship capital of the world

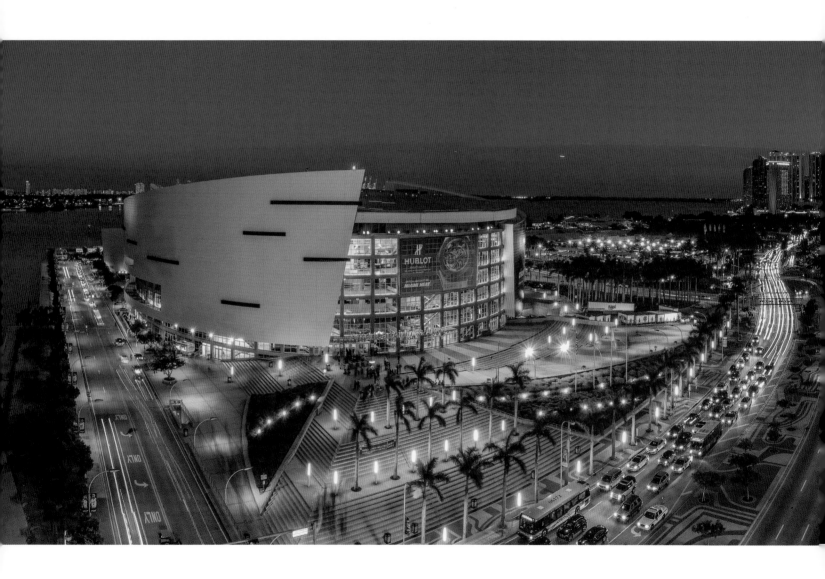

| Miami features many cutting edge architectural buildings.

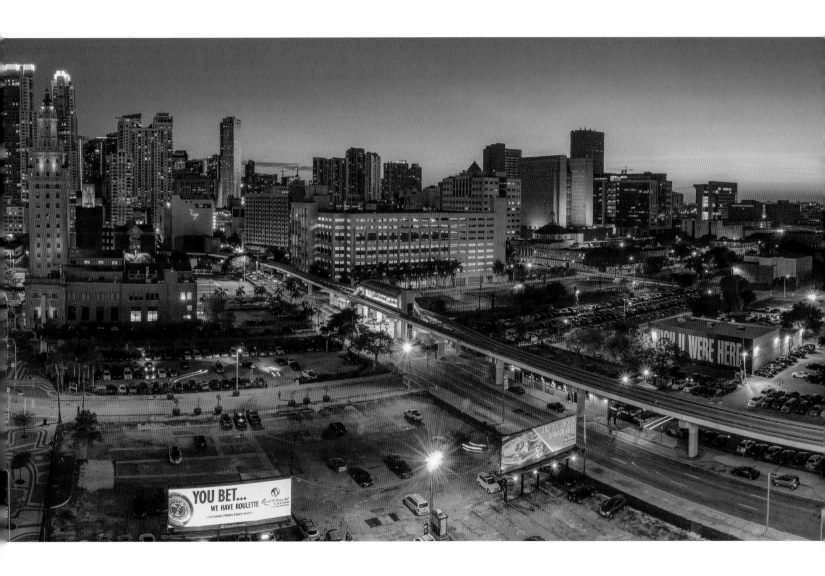

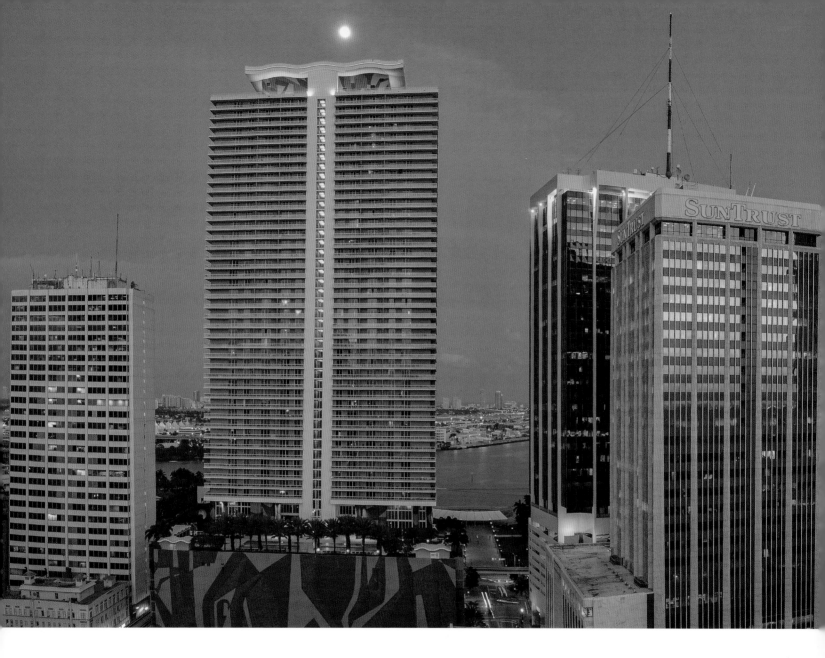

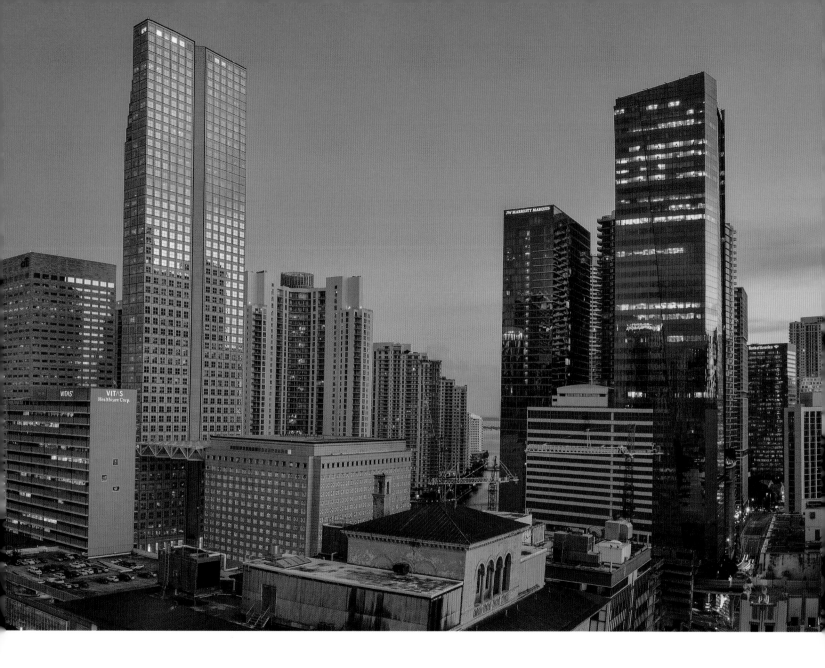

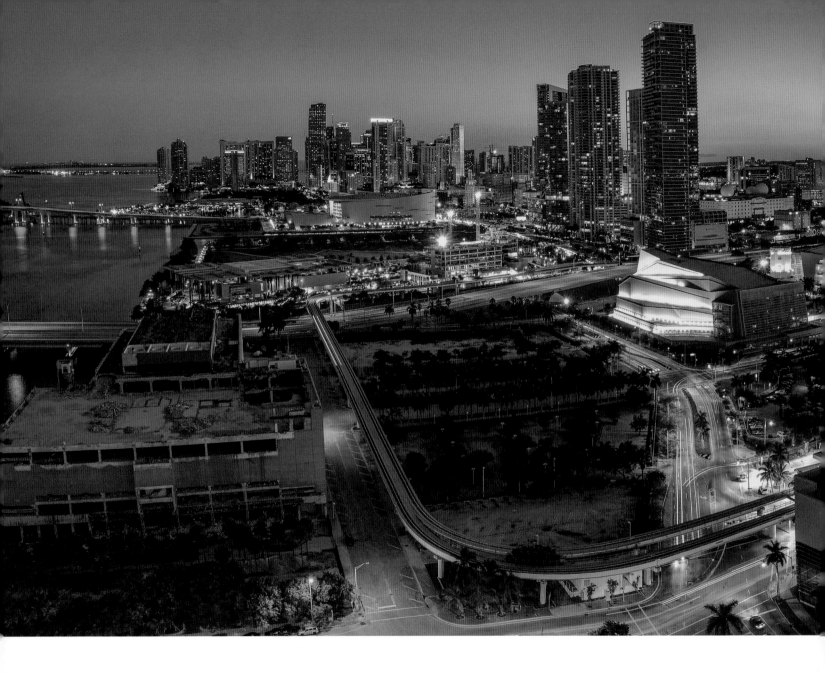

| Silky colors light the Miami night

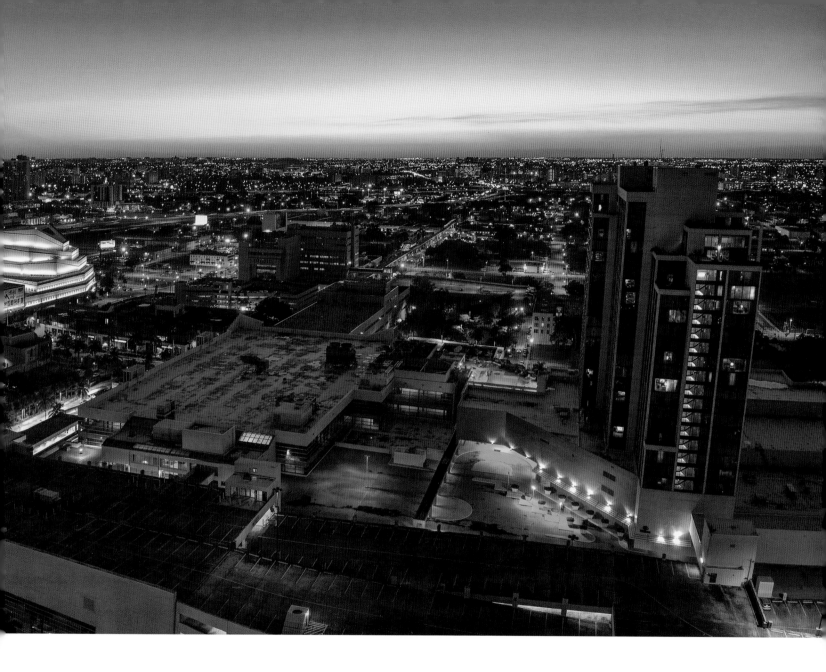

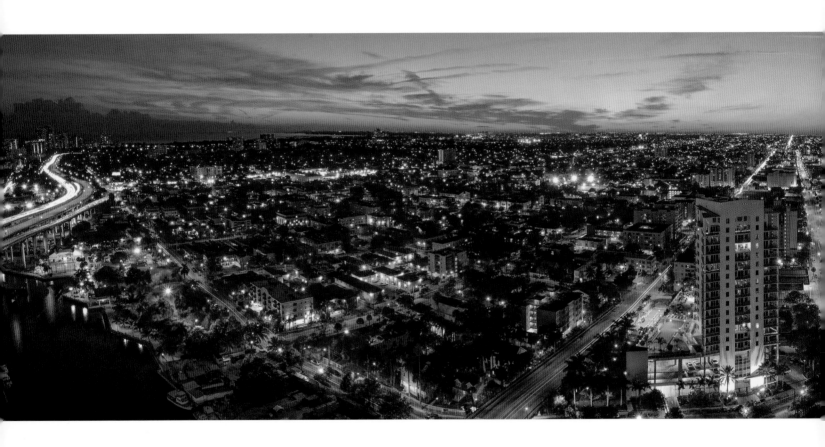

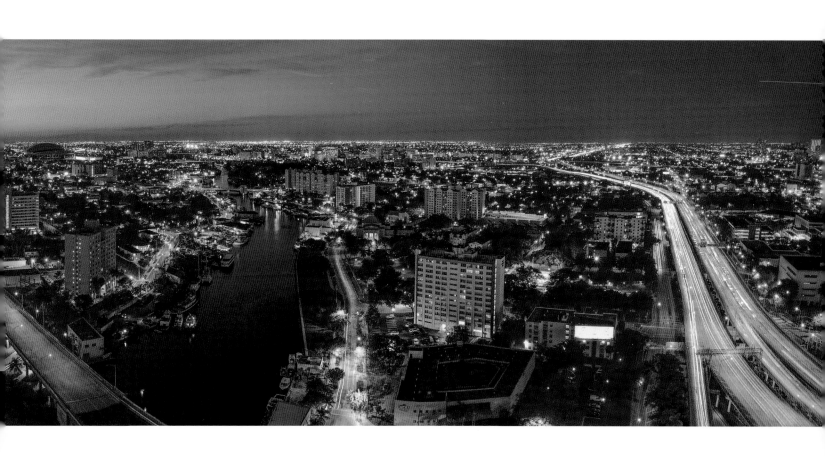

A beautiful sunset over Little Havana and the Miami River | 89

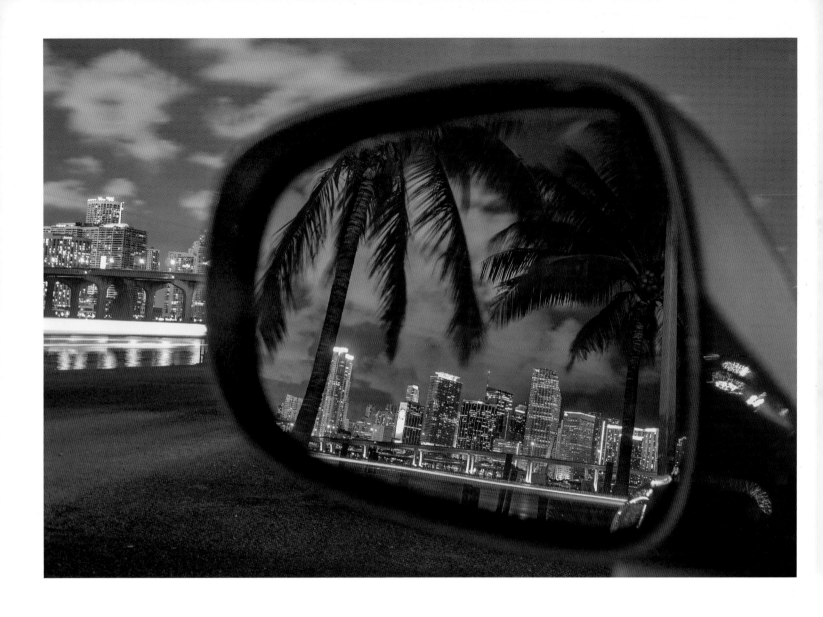

Downtown Miami's reflection from Watson Island

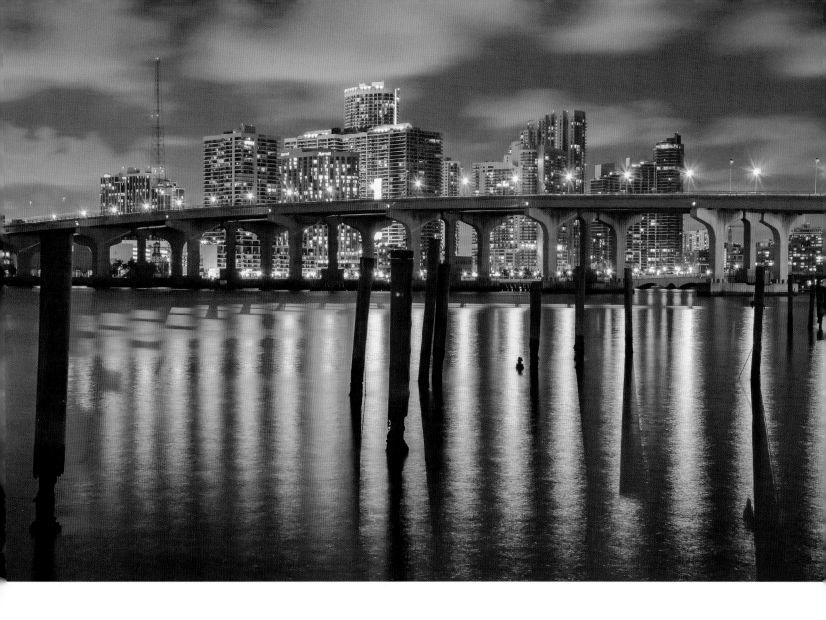

The Omni neighborhood of Miami lighting Biscayne Bay

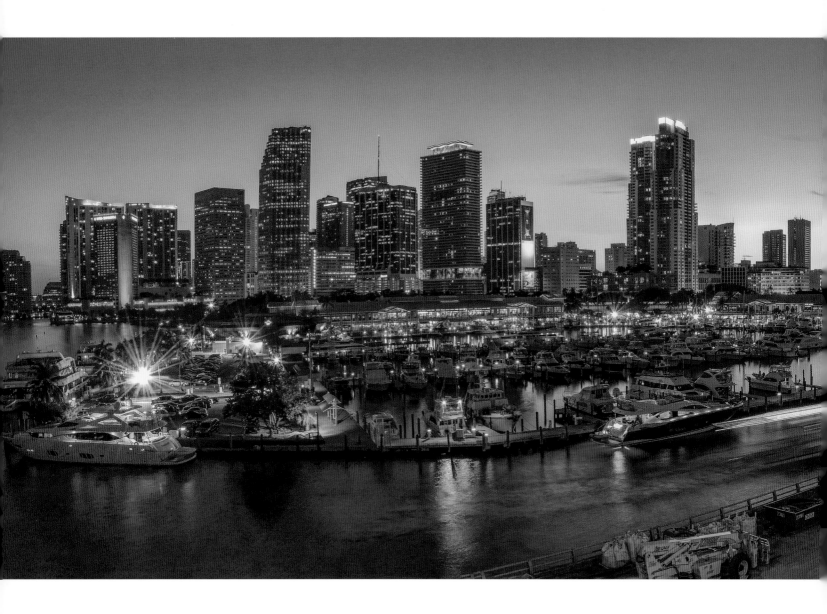

| Miami illuminated at night, with yachts docked at Bayside Marina

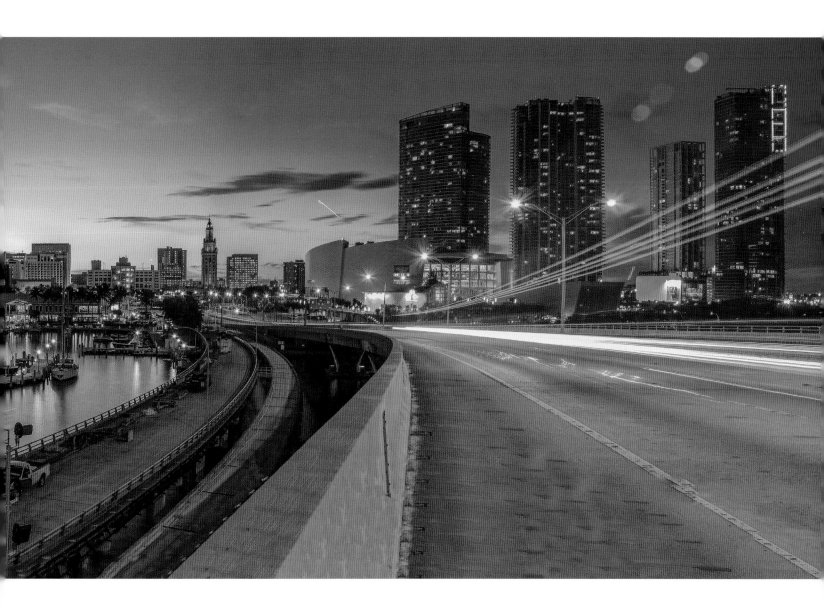

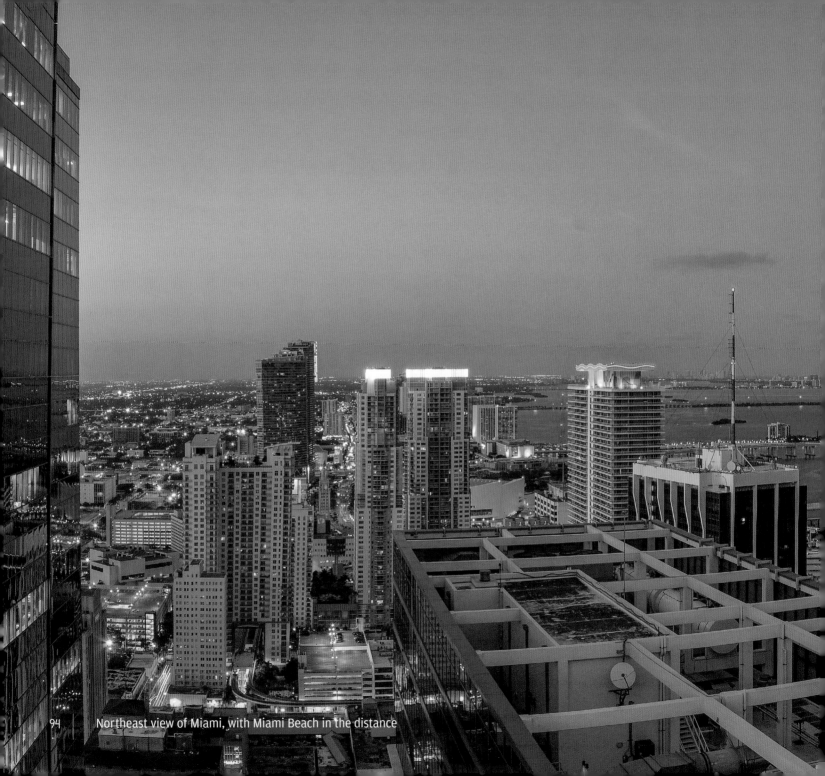

Northeast view of Miami, with Miami Beach in the distance

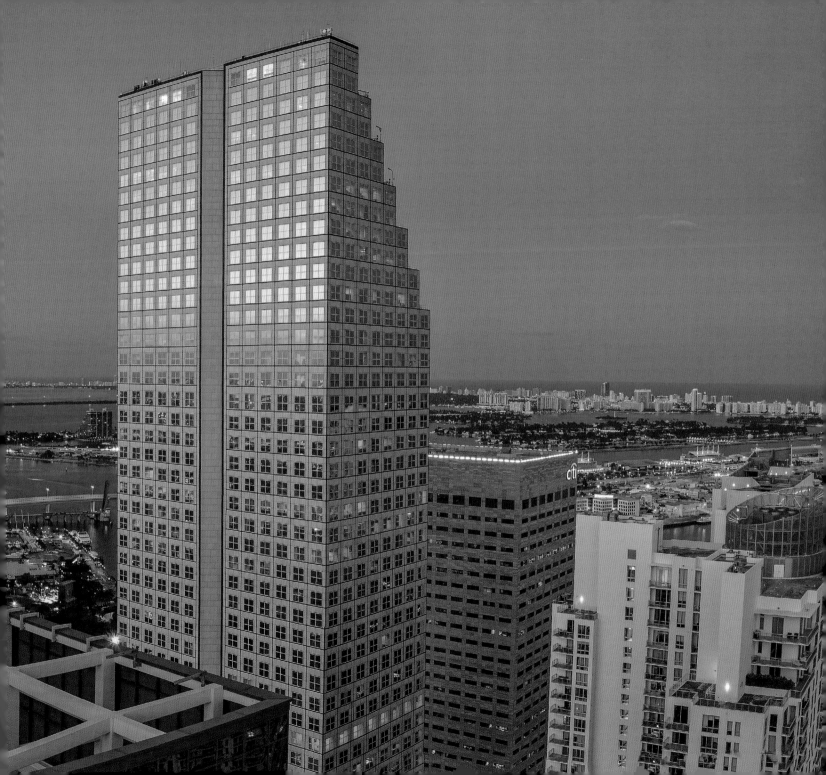

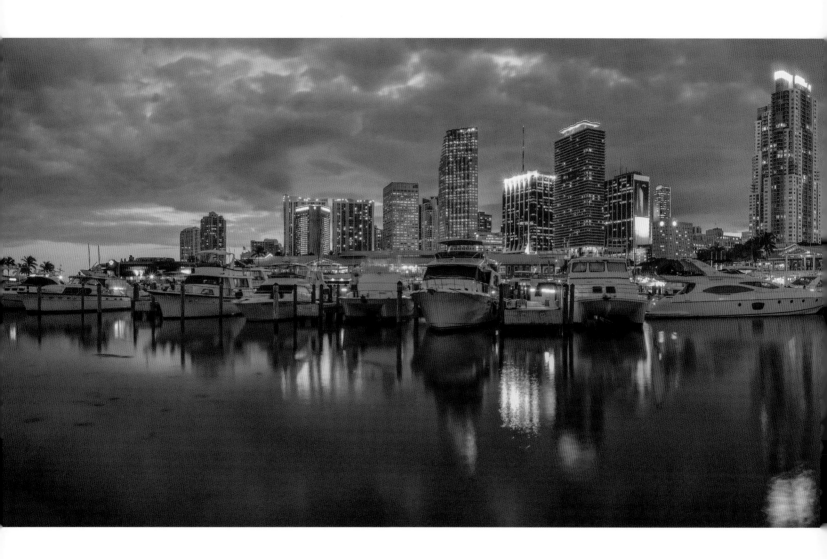

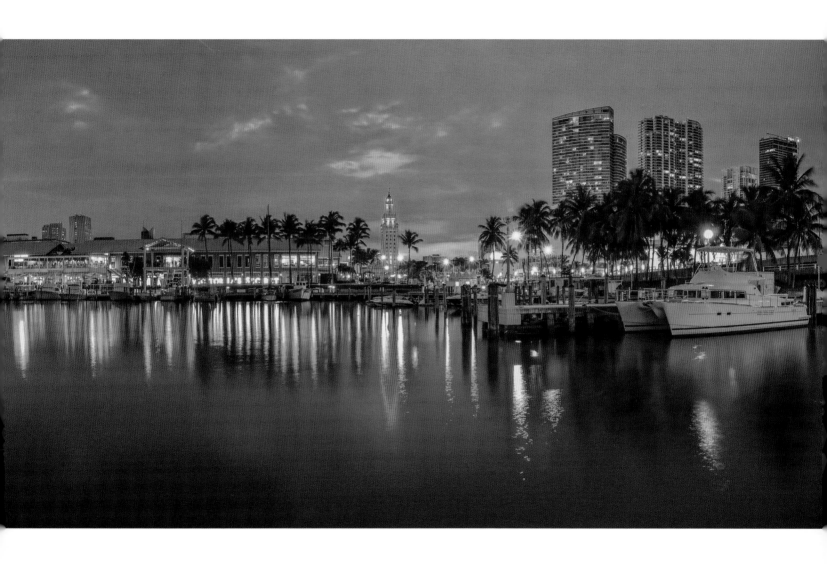

Bayside Marketplace opened in 1987, featuring an outdoor shopping plaza and marina.

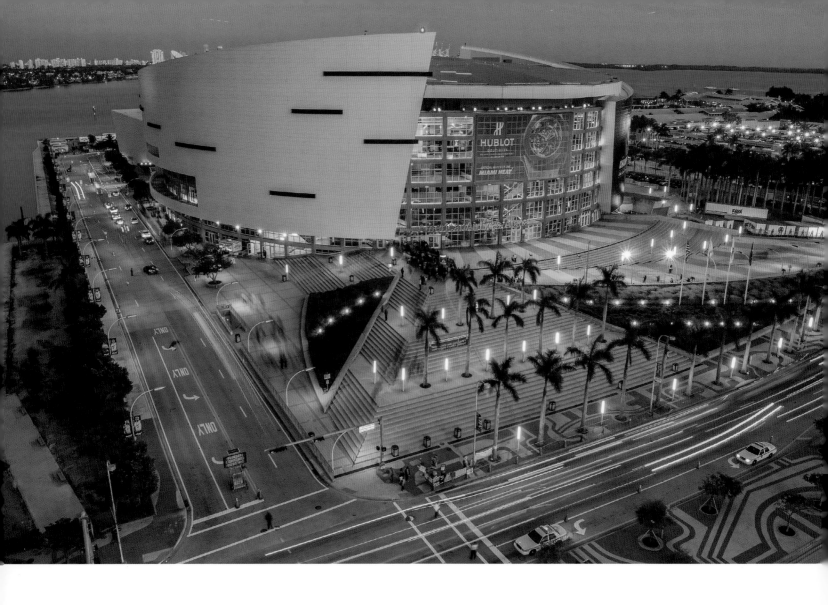

The American Airlines Arena, home of the NBA's Miami Heat

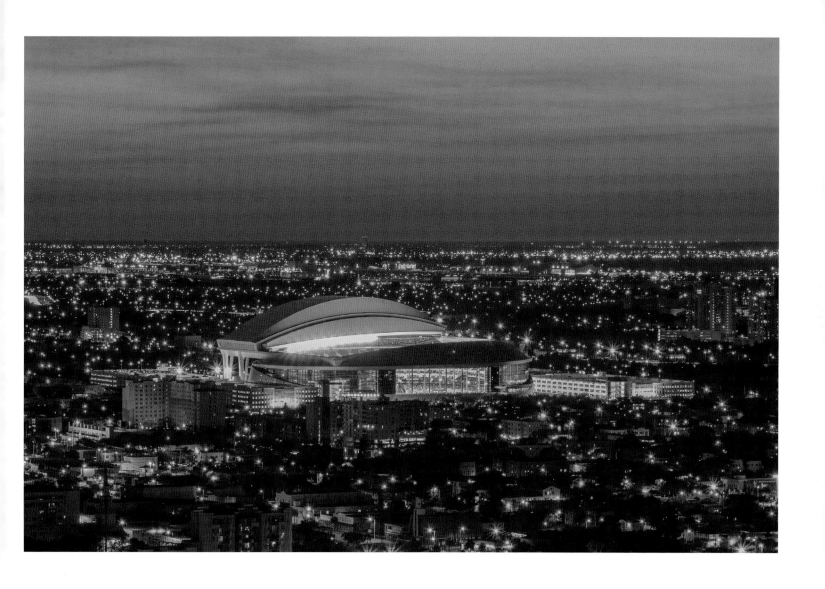

Marlins Park, home of the MLB's Miami Marlins

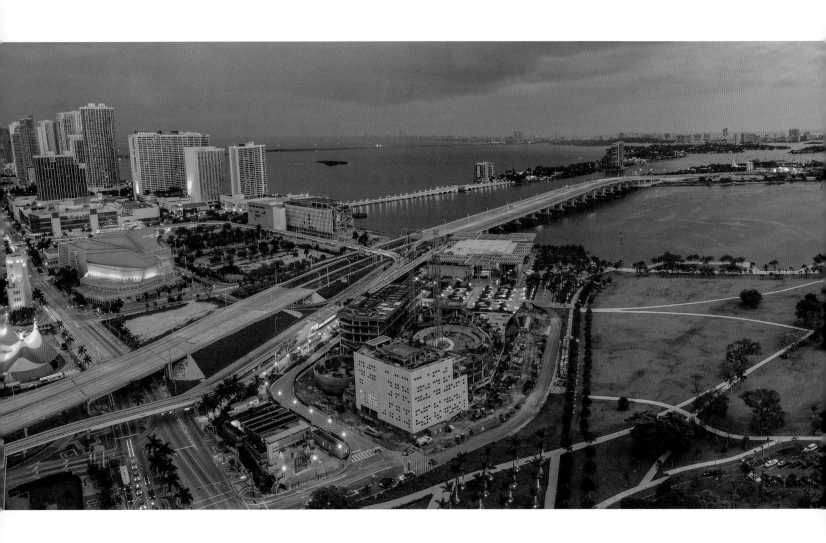

View of Biscayne Bay and Downtown Miami. In the foreground, construction is being completed on the Frost Museum of Science.

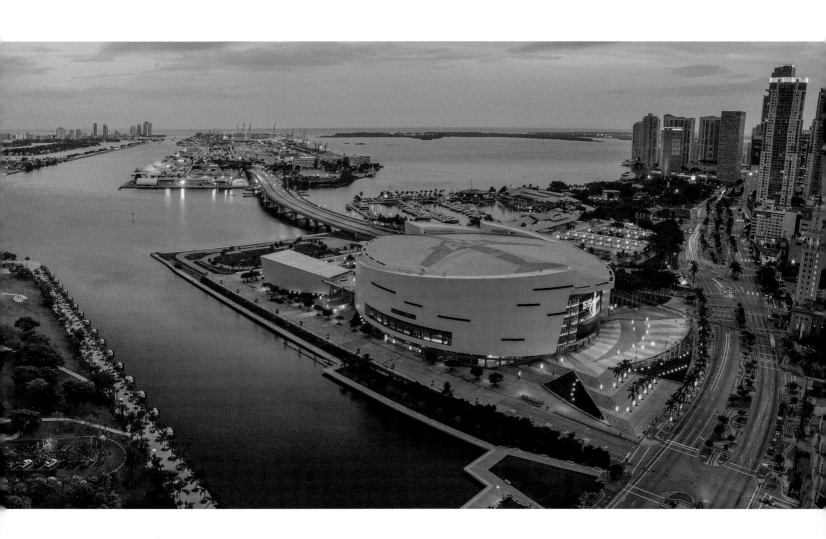

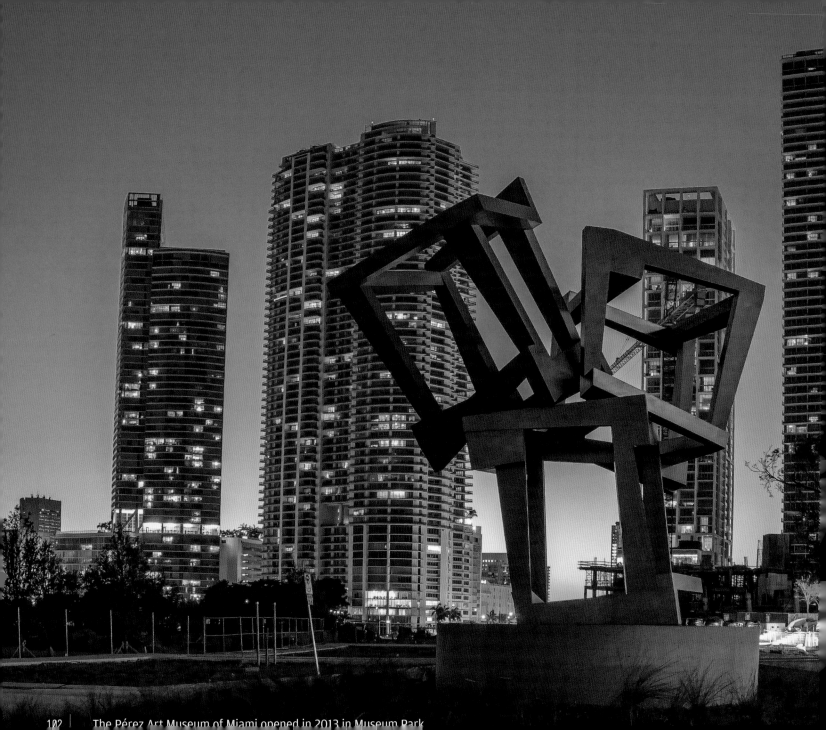

The Pérez Art Museum of Miami opened in 2013 in Museum Park.

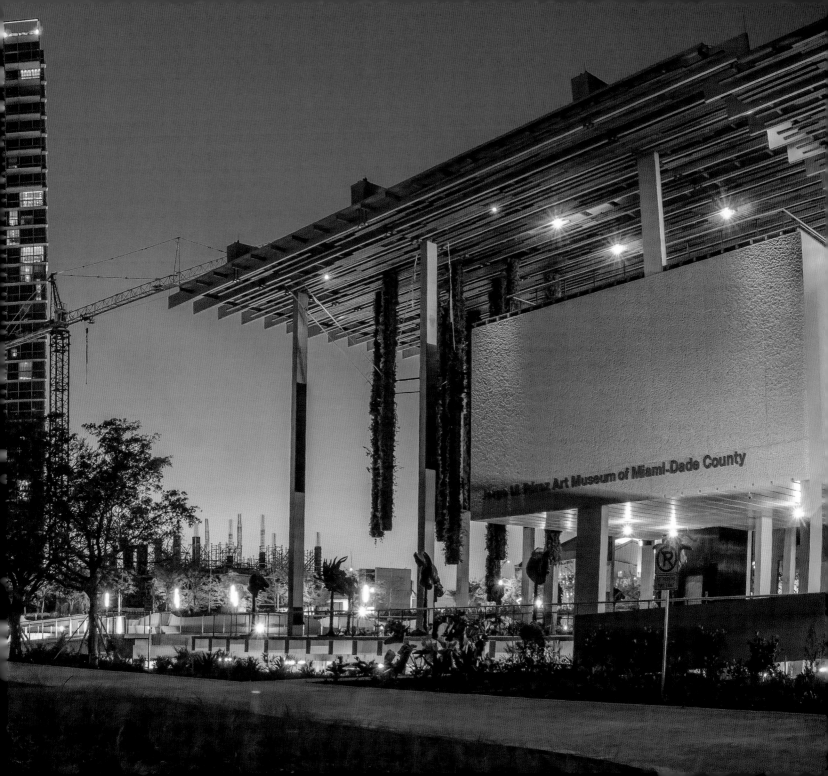

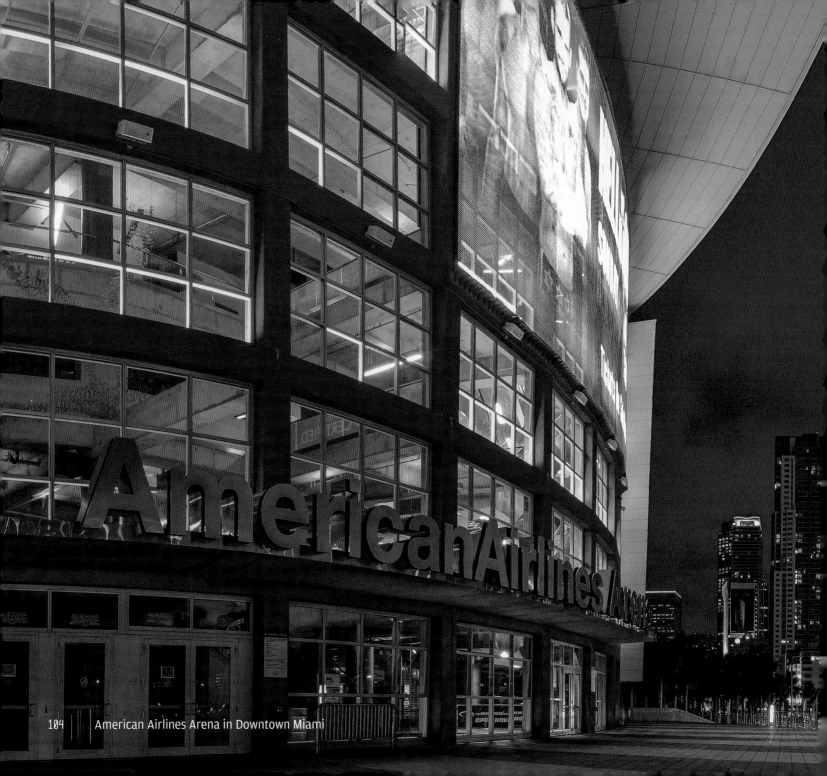

American Airlines Arena in Downtown Miami

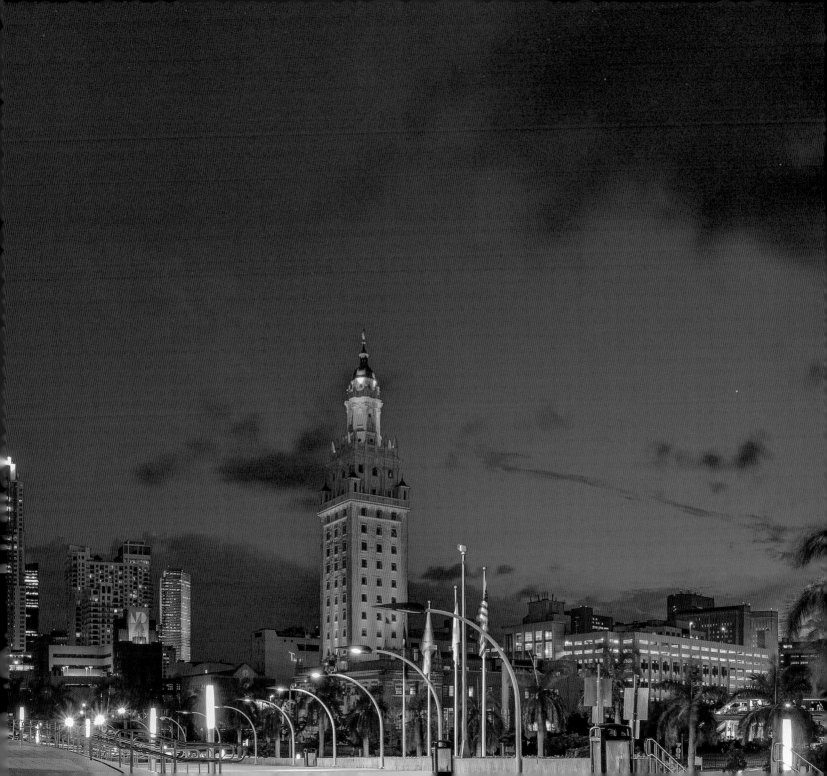

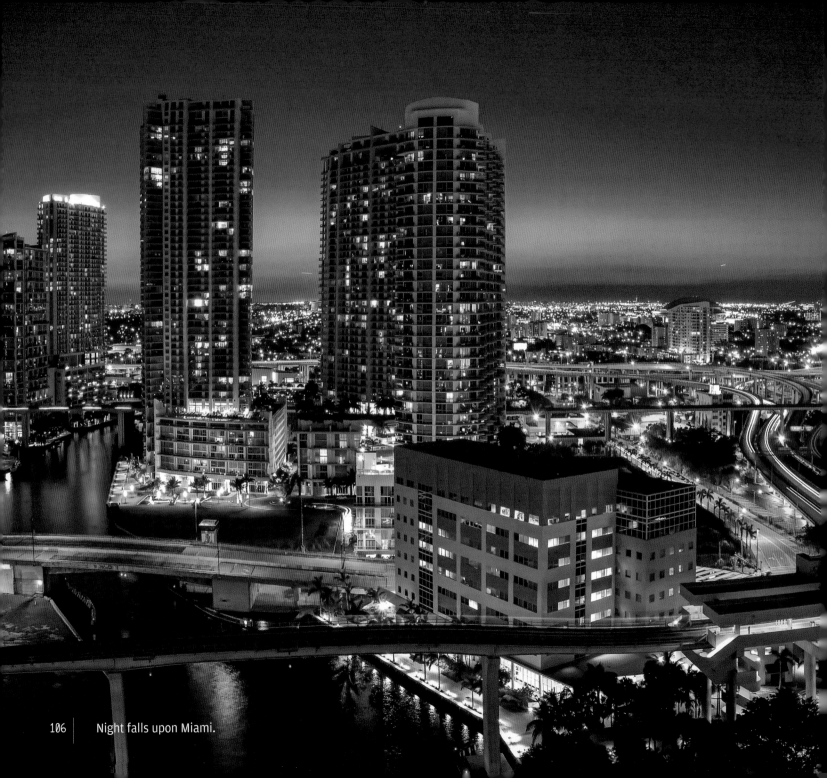

Night falls upon Miami.

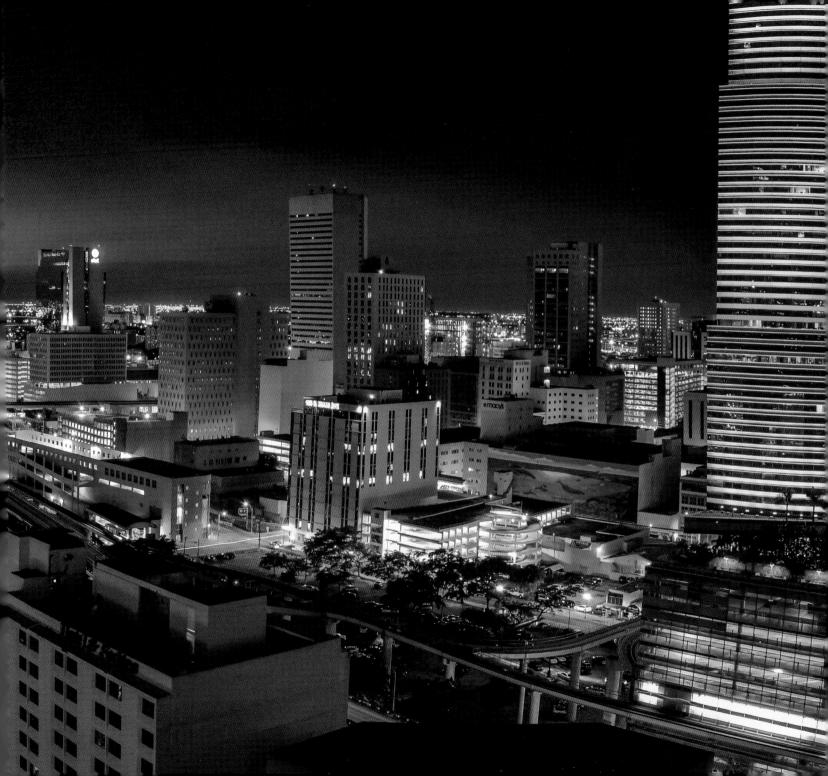

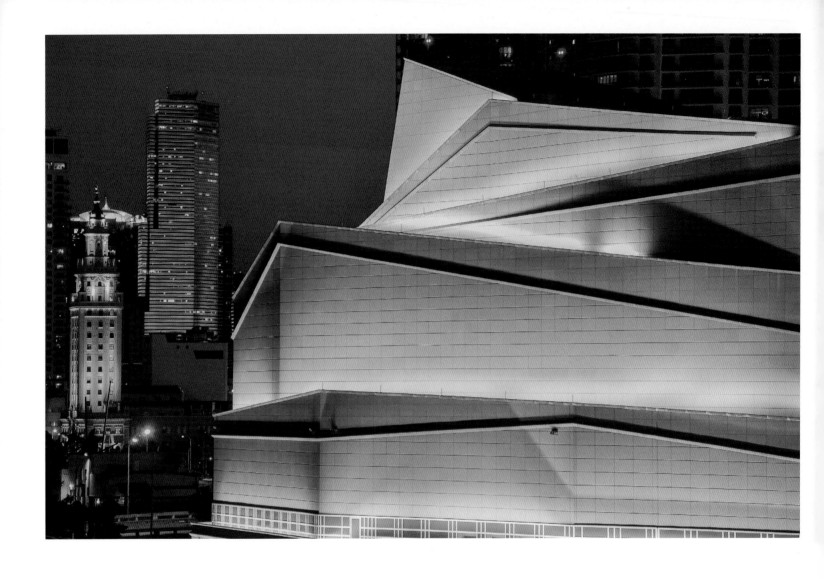

Miami architecture from the 1920s, 1980s, and 2000s

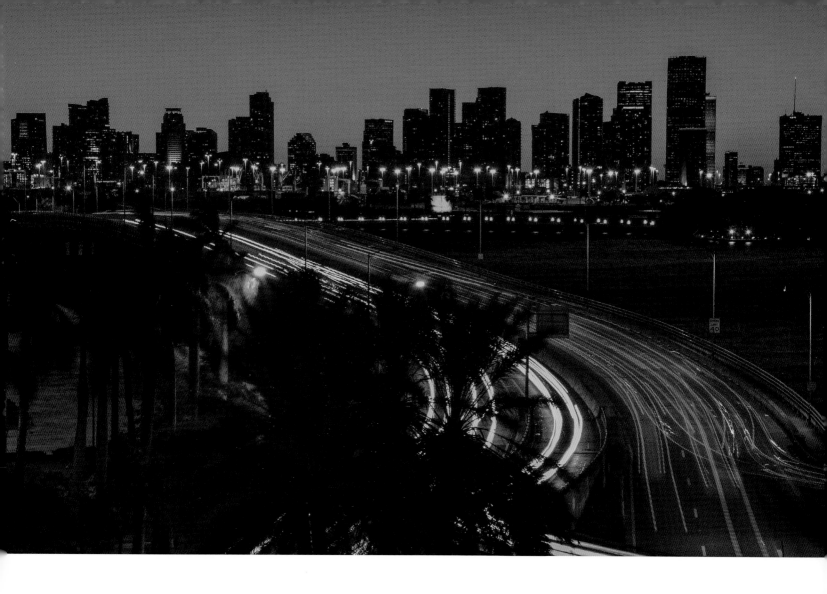

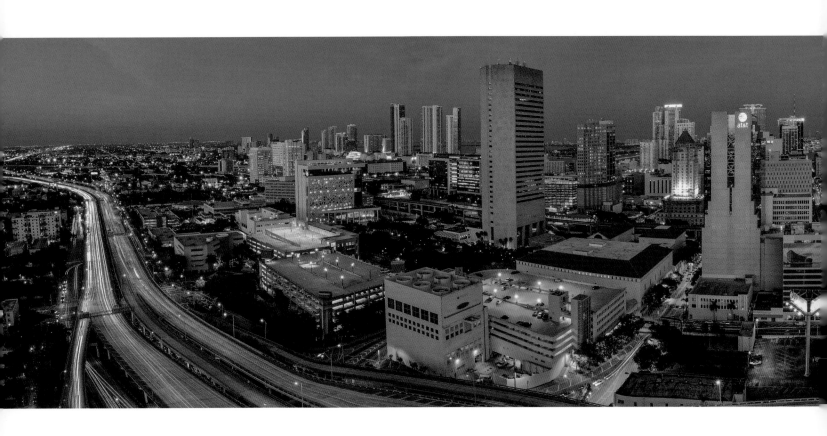

Downtown Miami and Brickell on a busy weekday night

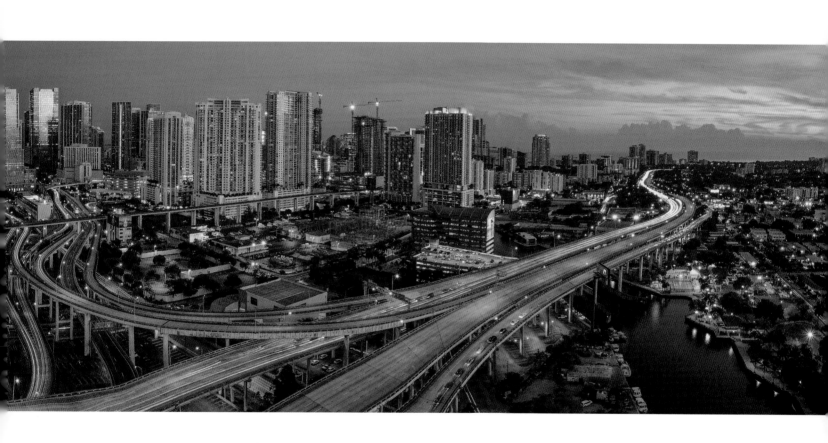

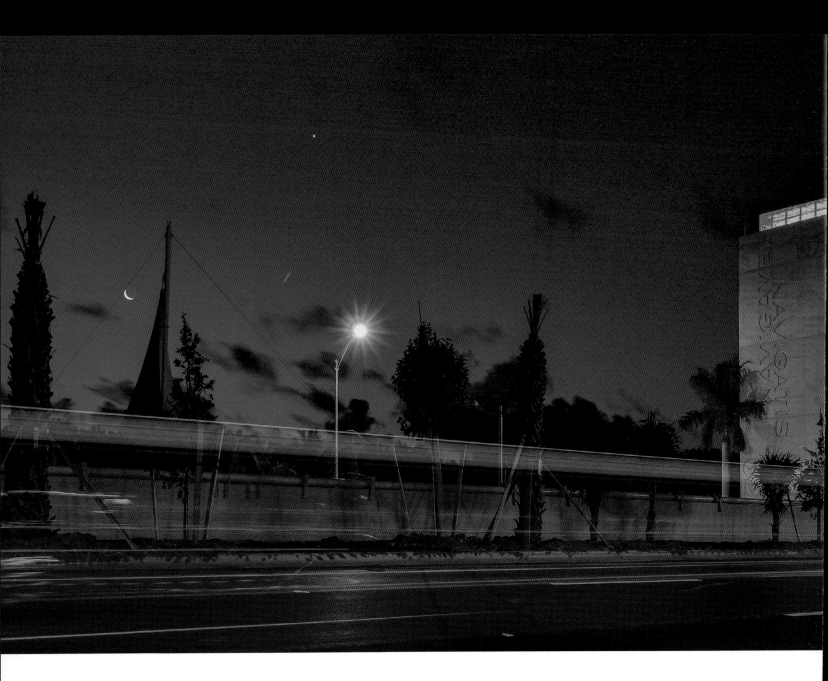

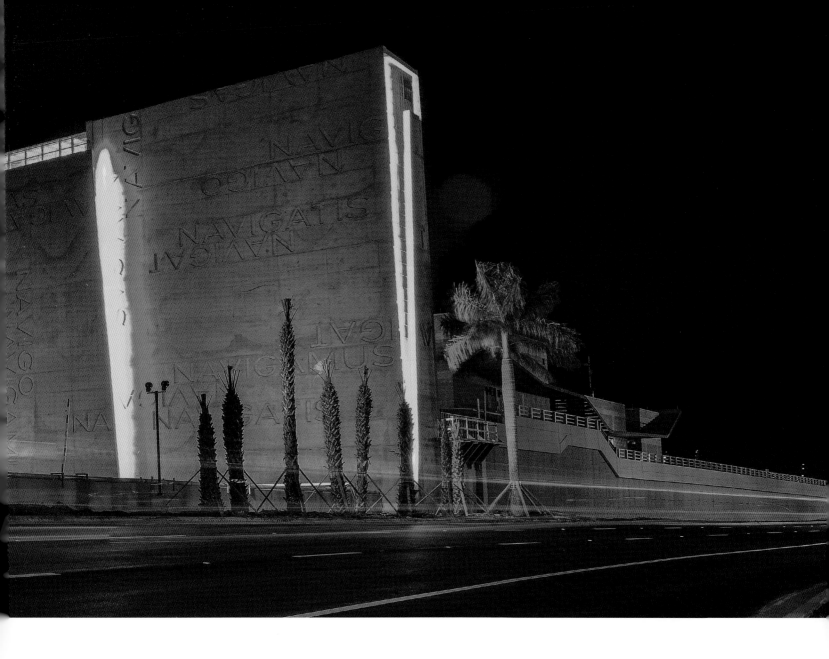

The entrance to the Port Miami Tunnel, which opened in 2014 |

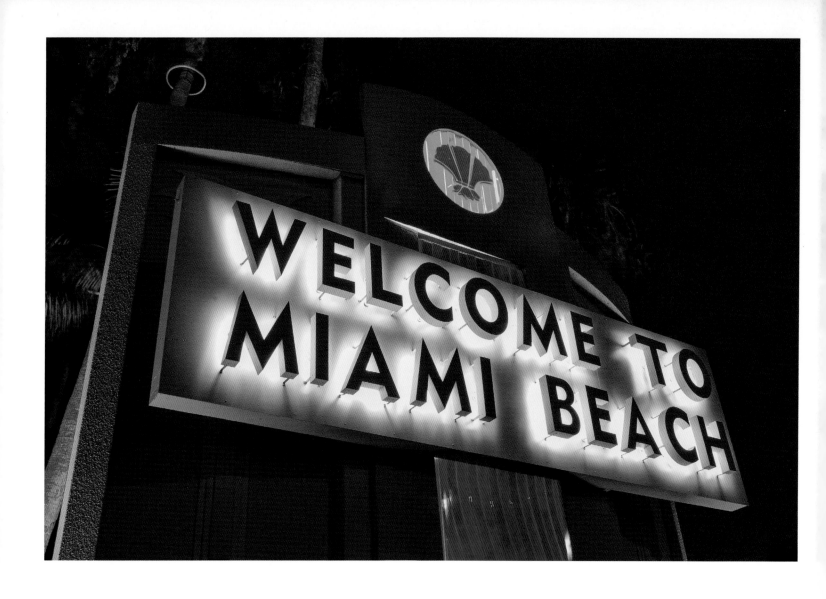

PART 4 MIAMI BEACH

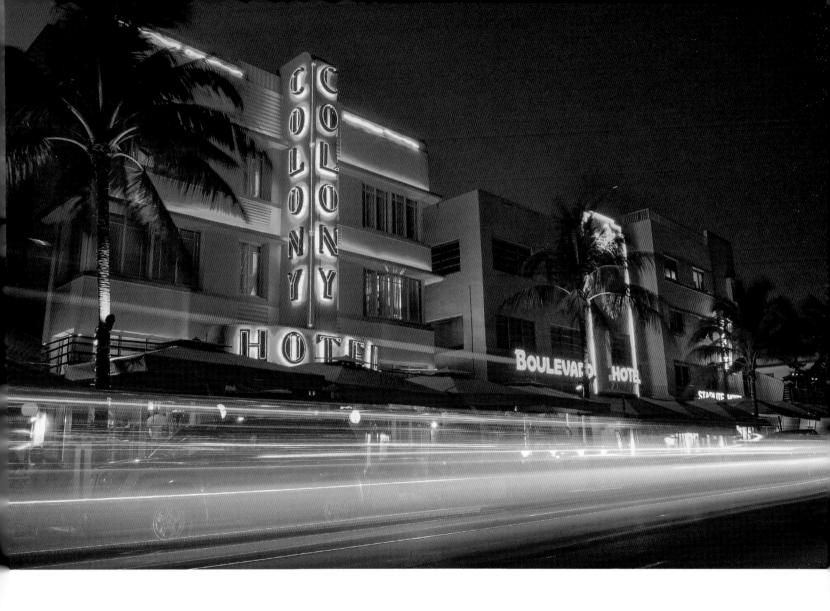

The famous Ocean Drive strip of South Beach

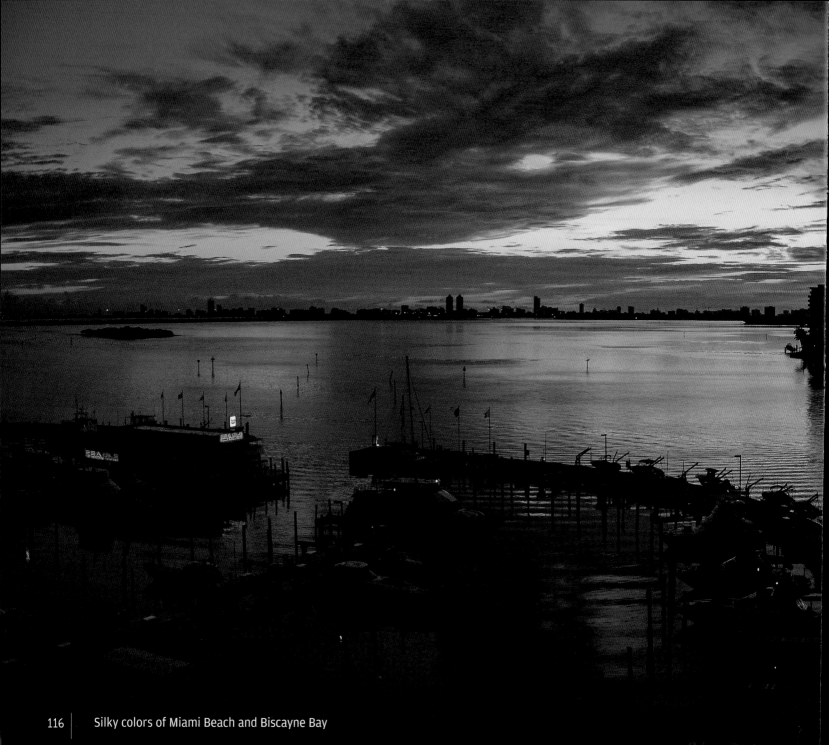

| Silky colors of Miami Beach and Biscayne Bay

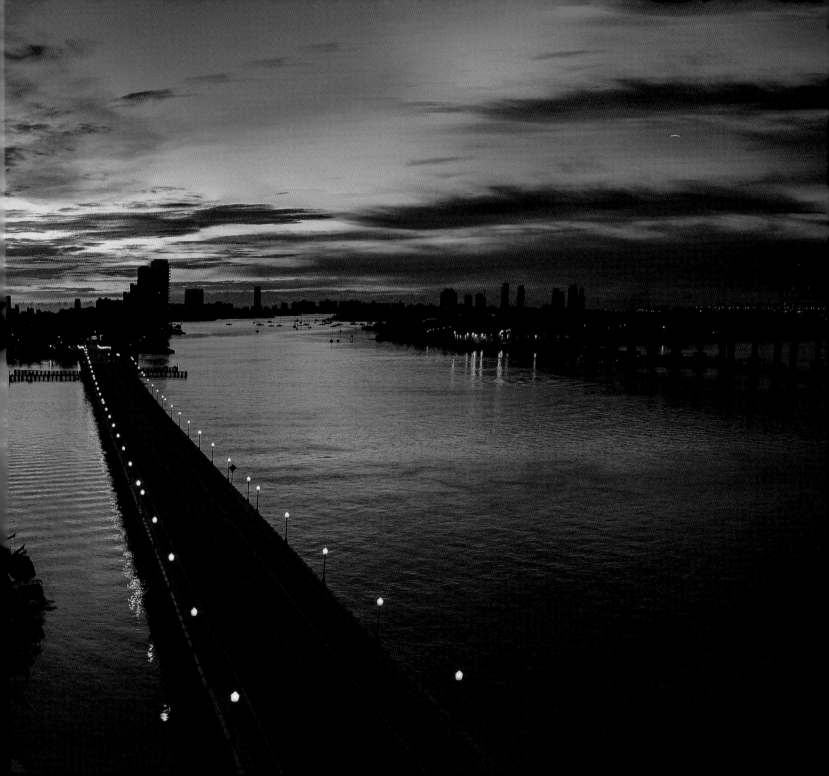

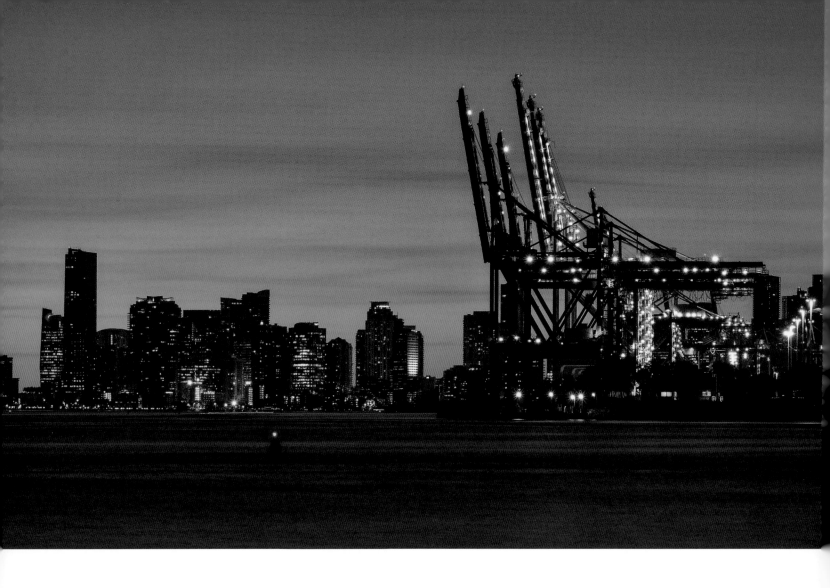

The Port of Miami and Brickell from South Pointe Park

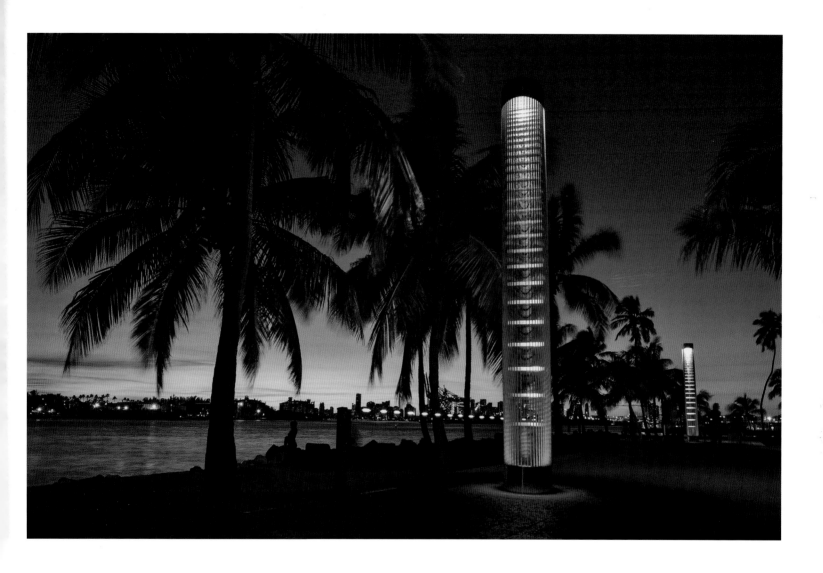

The neon lights of South Pointe Park on South Beach

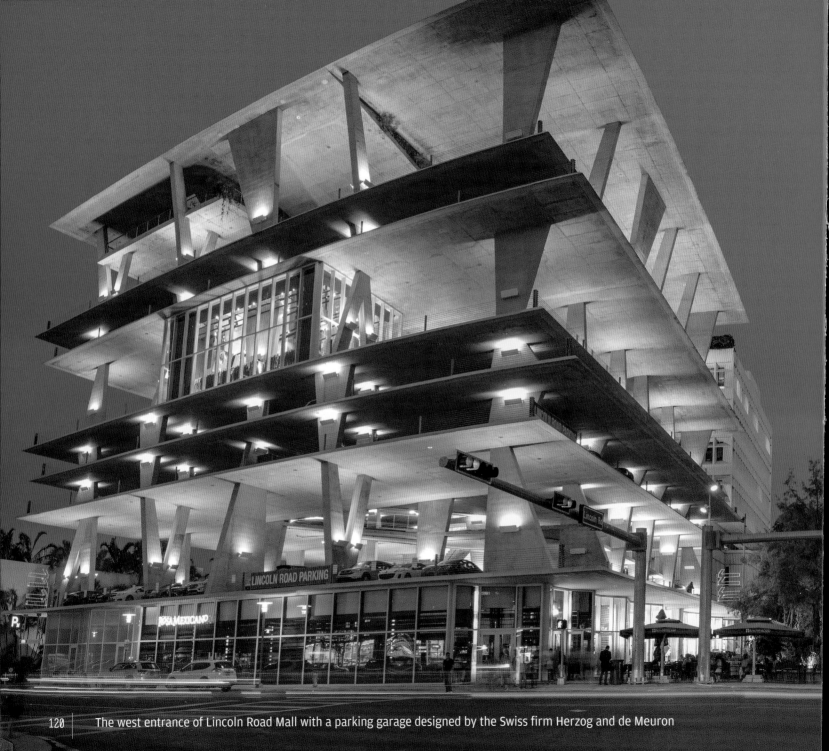

The west entrance of Lincoln Road Mall with a parking garage designed by the Swiss firm Herzog and de Meuron

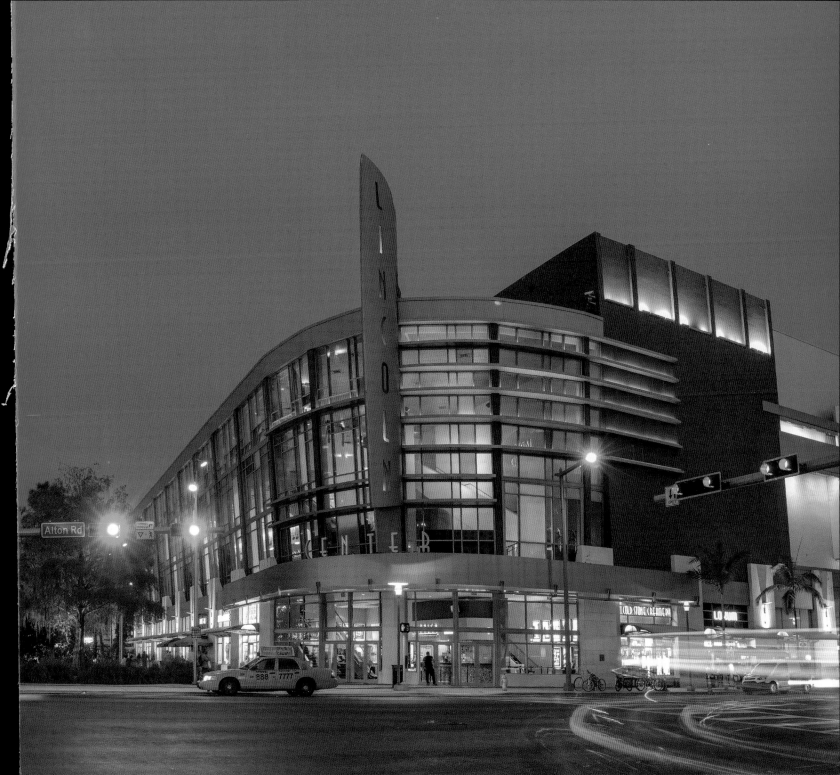

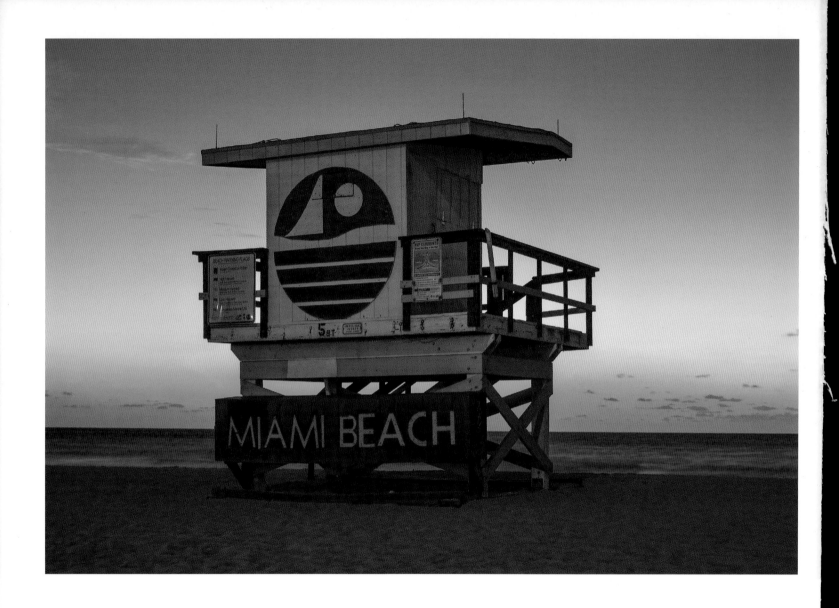

| One of the unique Miami Beach lifeguard stands

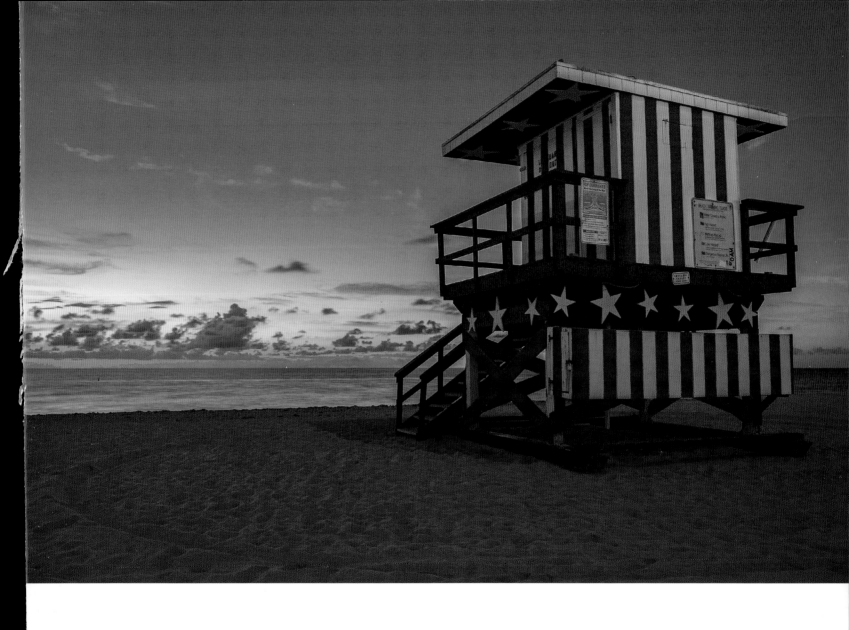

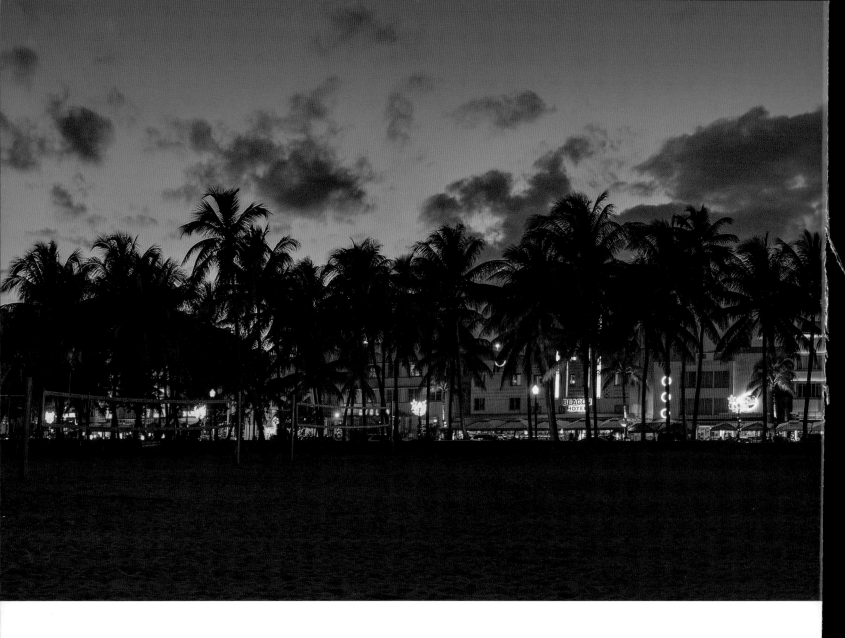

The colorful neon lights of Ocean Drive

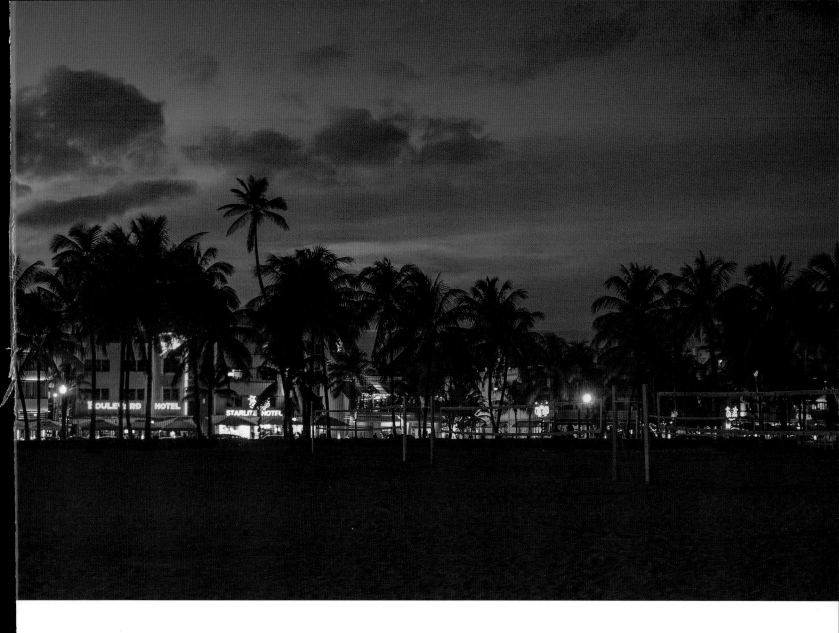

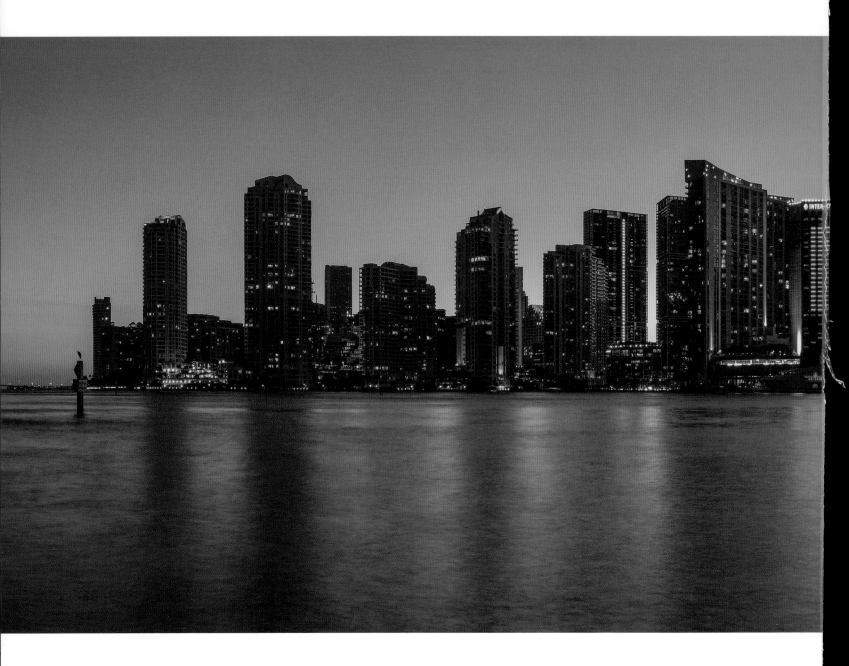

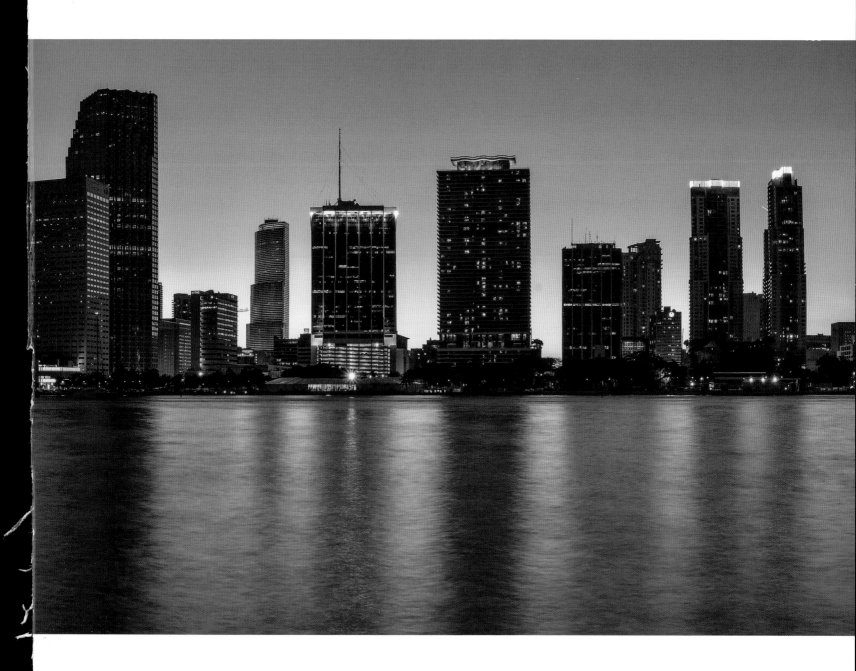

ACKNOWLEDGMENTS

Thank you to Shep and Anne Cynamon and Rodrigo and Erin Real for your support on the book.
Thanks to Pete Schiffer and the Schiffer Publishing team for making this book possible.